IMAGES
of America

KANSAS CITY,
KANSAS

IMAGES
of America

KANSAS CITY, KANSAS

Joe H. Vaughan

ARCADIA
PUBLISHING

Published by Arcadia Publishing
Charleston, South Carolina

Printed in the United States of America

Library of Congress Control Number: 2012939091

For all general information, please contact Arcadia Publishing:
Telephone 843-853-2070
Fax 843-853-0044
E-mail sales@arcadiapublishing.com
For customer service and orders:
Toll-Free 1-888-313-2665

Visit us on the Internet at www.arcadiapublishing.com

*To museum executive director Patricia Schurkamp, archivist
Jennifer McLaughlin, staff assistant Jeff Jennings, and volunteers
Monte Gross, Bennett J. Green, and James (Jim) Masson, without
whose knowledge, experience, technical background, perseverance,
and love of the joy of history, this book could not have been done.*

Wyandotte County Historical Society and Museum
Bonner Springs, Kansas
Mission Statement

To collect, identify, preserve, interpret and disseminate material and
information pertaining to Wyandotte County history in order to assist
the public in understanding, appreciating and assist in providing for
the permanent preservation of the heritage of this county.

CONTENTS

ACKNOWLEDGMENTS

All text, photographs, and statistical data appear courtesy of the archives of the Wyandotte County Historical Society and Museum (WCHS&M) in Bonner Springs, Kansas. I received technical advice and counsel from executive director Patricia Schurkamp, museum archivist Jennifer Laughlin, and museum volunteers Bennett J. Green, Marty Gross, and James (Jim) Masson. The WCHS&M was fortunate to obtain the entire image files (estimated at around 10,000 images) from the *Kansas City Kansan* daily newspaper when it abandoned its building at 901 North Eighth Street in 2008. Many of the images appearing in this book are from that collection.

A special thank-you to Arcadia Publishing for contracting with Joe Vaughan Associates of Prairie Village, Kansas, to author and edit this book. And a special thank-you to my editor, Simone Monet-Williams, who patiently helped me throughout the entire process.

INTRODUCTION

Kansas City, Kansas, has a broad-ranging and fascinating history. It grew out of the lush plains and plentiful water supply of two rivers surrounded by open, fertile land, wild flowers, and plentiful animals to become one of the Midwest's economic and industrial behemoths. By 1900, it had a population of just over 50,000 people. It prospered as an industrial, rail, residential, retail, and business center and was the most-populous city in Kansas for the next six decades.

Kansas City, Kansas, then went through a long period of decline very similar to other aging urban centers in the Midwest and Northeast. A vastly different economy emerged after World War II across the nation, reflected in Kansas City, Kansas, by the slow death of the stockyards following the Great Flood of 1951, and the related Rust Belt industrial decline. With the development of suburban municipalities, social struggle and integration following the Supreme Court's 1954 *Brown vs. Board of Education* decision, and subsequent white flight in the 1960s, every aspect of Kansas City, Kansas, life was altered.

But the beginning of the 21st century saw the city experience a resurgence that few urban centers have enjoyed. Since 2000, over $100 billion in new developments have rejuvenated Kansas City, Kansas, into a dynamic vacation and retail destination attracting 10 million visitors annually. The most significant announcement came in 2011, with California-based Google's choice of Kansas City, Kansas, over 1,100 other communities, to establish the headquarters for its first test market for a fiber optic cable, with the goal of eventually connecting every home in the nation to the Internet.

In early 2012, Cerner Corporation broke ground on a campus, including two 10-story towers, that is expected to bring 4,000 new high-paying jobs to the city.

The first recorded documents of the future city and state relate to Lewis and Clark, in 1804. Pres. Thomas Jefferson hired explorers Meriwether Lewis and William Clark to begin charting the Louisiana Purchase, which had been acquired from the French in 1803. The vast, uncharted territory stretched hundreds of miles, from the Gulf Coast northwest to the Canadian border.

As the Lewis and Clark expedition headed northwest in 1804, one of its major encampments was established at the mouth of the Kansas (also known as the "Kaw") River where it empties into the muddy Missouri. The explorers also stayed there on their return journey in 1806. Now a historic site, it is referred to as Kaw Point Riverfront Park, at the east end of downtown Kansas City, Kansas, just north of Interstate 70 at the Fairfax Exit. A marker was placed in the park, and a regional celebration occurred on the site during the 200th anniversary celebration of the expedition. The park is on the National Register of Historic Places.

A half-century later, and a few hundred yards to the west of the encampment, the Kansas constitution, on the fourth try, on a hot, steamy day in July 1859, was completed and signed by delegates in the Meyer-Leipmann building. It provided for Kansas to be admitted to the Union as a free state. Following a territorial vote to approve the document, it was submitted to Pres. James Buchanan. Kansas became the 34th state on January 29, 1861. The four-story Meyer-Leipmann Hall, where the

convention was held and the document signed, was near present-day Fourth Street and Nebraska Avenue. It was the tallest building in the Kansas territory at that time.

Among the now-gone buildings, sites, and scenes readers will encounter in this book are two four-year universities, a glitzy family amusement park, and a sunken garden surrounded with native limestone walls that stretched for several blocks along the west side of downtown. There was a vaudeville stage theater with an orchestra pit and three balconies, and many other high-qualities of life and stylish amenities not documented and tied to available published histories of Kansas City, Kansas. Some of these sites were lost during the Great Depression, others to poor management, and still others to the unavoidable trends and ever-changing tastes and interests of the community.

The dramatic 21st-century reemergence of Kansas City, Kansas, 200 years after Lewis and Clark, is echoed in the leap from the signing of the state constitution to the arrival of Google, Cerner, and a world of technology. All of this makes for an exciting chronicle of a Midwestern city's history.

This book is intended to be a pictorial history of many of the city's buildings and significant sites that no longer exist, and of the features of a new city in a new era. It will not include politics, sports, and personalities, or religious, cultural, or ethnic topics. Several detailed books addressing these issues have been written and are available through the bookstore at the Wyandotte County Historical Society and Museum and at the Kansas City, Kansas, Public Library. Schools have not been included because a detailed history of the Kansas City, Kansas, public schools (with photographs of many schools) by well-known historian Patricia Adams can be viewed at www.kckps.org. As this book focuses on a specific municipality, the other incorporated cities in Wyandotte County, Bonner Springs and Edwardsville, were not included. Those two cities are a part of what officially became the Unified Government of Wyandotte County/Kansas City, Kansas by public vote in 1997. Each continues to be a third-class Kansas municipality, however; and each retains its own mayor and city council under Kansas statutes.

This is intended to be a fun book, designed to reacquaint some readers with memories long forgotten and to introduce present and future generations to the significance Kansas City, Kansas, played as a "full-service" city in the Midwest. The book highlights the many economic contributions the city made to the early development of the United States and the revitalized 21st-century magnet of challenge and opportunity it is becoming today.

Read . . . view . . . remember when . . . learn . . . and have fun!

One

Two Centuries
of Civilizing
the New West

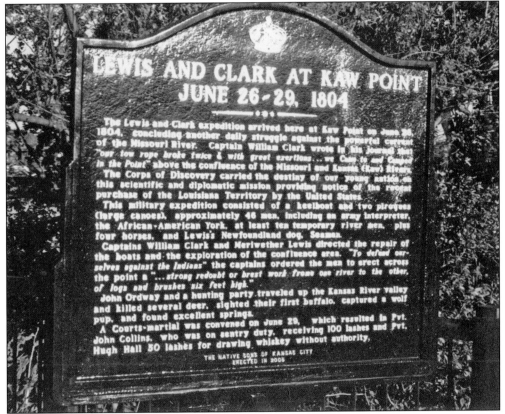

This marker at Kaw Point was placed in 2005 during the celebration of the 200th anniversary of the Lewis and Clark expedition. Three key members of the expedition are rarely mentioned: Sacajawea, an indigenous woman, served as a guide on the two-year trek; York, a black slave, also connected with others who had never met non-indigenous people; Seaman, a dog, with his acute hearing and smelling abilities, conquered foxes, wild dogs, bobcats, and dozens of other four-legged predators who awaited the explorers in tall brush, thickets, and bushes along the hundreds of miles of raw land that had never been mapped.

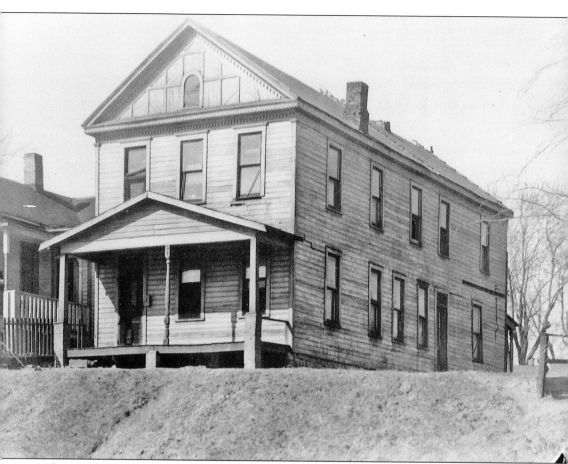

This wood-frame house was converted into Wyandotte County's first courthouse sometime after the state constitution was signed in 1859. The courthouse was located at 329 Nebraska Avenue, less than a block from the signing site. This would remain the courthouse until a permanent structure was dedicated in 1883 at 700 Minnesota Avenue.

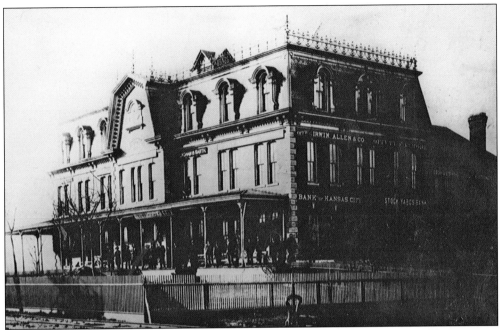

The first Livestock Exchange Building, shown here, opened in 1871 at the present-day intersection of Industrial Park Drive and Kansas Avenue, just outside of the city limits of the new Kansas City, Kansas. The 1903 and 1908 floods resulted in second and third headquarters buildings being constructed, and a move across the line into Missouri. The present building, at 1600 Genessee Street, was constructed in 1911. It is now used as a commercial office building, because the stockyards closed down in 1991.

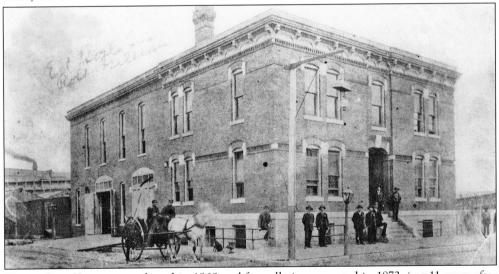

Kansas City, Kansas, was platted in 1868 and formally incorporated in 1872, just 11 years after statehood. Not long after being granted corporate status, the first city hall (shown) in Kansas City, Kansas, was built on the east side of James Street, between the Missouri state line and the Kansas River. James Street is still there, but the building's exact street address has been lost. Following the city's 1886 consolidation with four smaller towns, this city hall was demolished to make way for the Armour Meat Packing House, which was demolished in the mid-1960s.

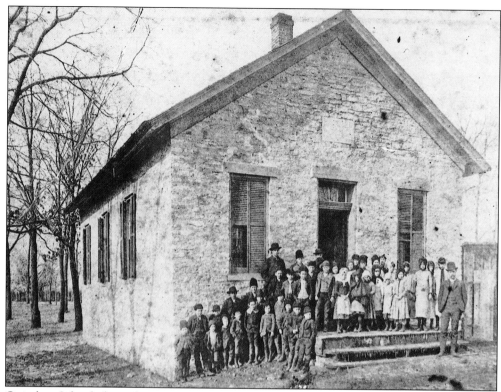

Quindaro School, shown here, was near present-day Twenty-seventh Street and Farrow Avenue. It was integral to the old town of Quindaro (1857–1862), whose heyday occurred just before the Civil War. Slaves were reportedly carried across the Missouri River from the slave state of Missouri to the promise of freedom in the soon-to-be free state of Kansas. Museum records indicate that Quindaro School was opened in 1858 and survived many years after the Civil War before closing in 1884. The nearby Quindaro Ruins are on city, state, and federal registries to serve as documentation of the struggle blacks went through to attain freedom.

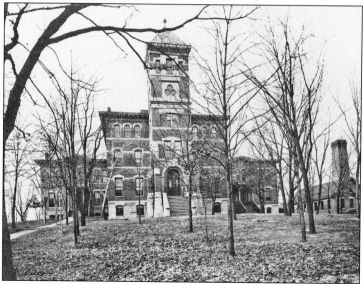

The State School for the Blind was opened in 1867 on a four-square-block area bounded by Eleventh Street on the east, Twelfth Street on the west, and from Washington Boulevard south to State Avenue. The administration building, shown in the photograph, was completed in 1884. The stately structure was demolished in 1950 to make way for new facilities.

The Consolidated Kansas City Smelter and Refining Company began operations in Argentine in 1880. It occupied an 18-acre site northwest of present-day 22nd Street and Metropolitan Avenue. It refined ores such as zinc and pig lead, and bullions—both gold and silver. The ores came in by rail from Old Mexico and Colorado. The smokestack (shown being demolished in 1958) was 187 feet tall and was composed of over 700,000 bricks. A changing industrial environment resulted in the smelter being shut down in 1901. The Kansas City Structural Steel Company then occupied the site from 1907 until 1996—a period of 89 years. The property has been vacant since. Both companies reportedly employed more than 500 people when at peak operation.

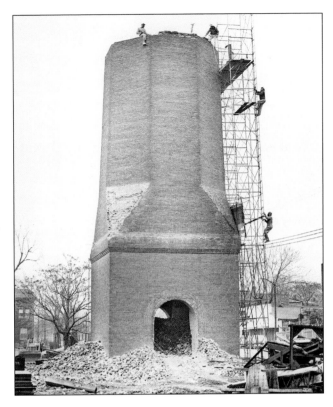

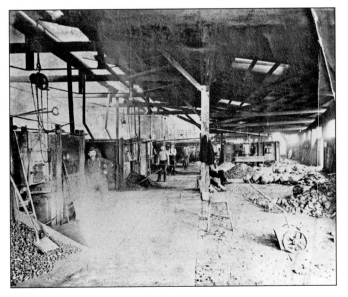

Smelter work was a hot, dirty, and dangerous way to make a living. In addition to laborers, foremen, and supervisors, the industry employed well-paid people degreed in the science of metallurgy and mining engineering. Sophisticated knowledge was needed in the refining process to evaluate and maintain quality control. "Free silver" became a major issue in the 1896 presidential campaign. The subsequent demonetization of silver made such operations obsolete. Five years later, the Argentine smelter shut down.

13

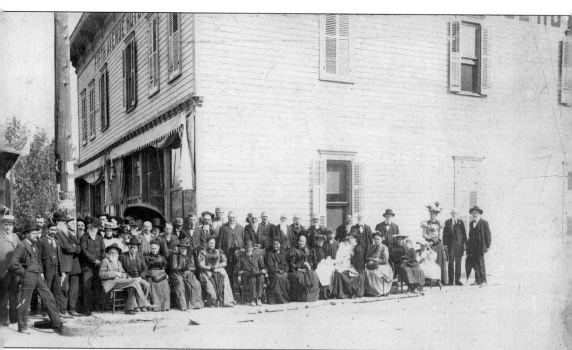

Argentine, Kansas, was a complete city and major stop on the Santa Fe Railroad in the late 1800s. Many important meetings were held at the Fifth Avenue Hotel (near present-day Twenty-fourth Street and Strong Avenue) in downtown Argentine. The photograph shows one such group in 1887. Major floods in 1903 and 1908, and the loss of over 500 jobs at the silver smelter in 1901, were among the many reasons Argentine merged with Kansas City, Kansas, in 1910.

On a hot, humid day in the summer of 1888, Republican presidential candidate Benjamin Harrison addressed the Republican Club of Rosedale, Kansas. Campaigns then were traversed by stagecoach or rail—no airplanes, no air-conditioned cars, and travel between cities took days. Harrison went on to win Kansas and the White House in November 1888. He has the distinction of being the only president to be succeeded by his predecessor: Grover Cleveland. Note the sign in the photograph announcing that "Hard Cider" is available to battle the heat and humidity!

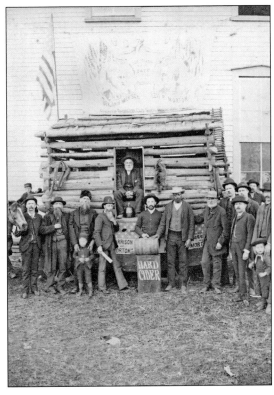

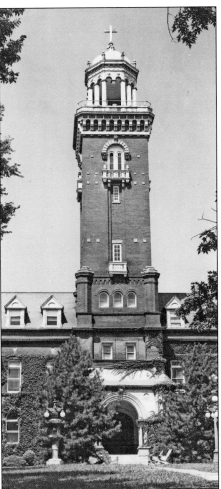

The Kansas City University (KCU) opened in 1894, at 3301 Parallel Parkway. Pictured here is Mather Hall, the administration building, named after Samuel Mather, who donated the 22-acre site. The building is in the Richardson Romanesque style and was designed by Vrydagh and Wolfe Architects of Pittsburgh, Pennsylvania. Heinz Hall, on campus, was financed by a donation from H.J. Heinz, the food products manufacturer from Pittsburgh. KCU went bankrupt during the Great Depression. In 1934, the Augustinian Recollect Order purchased the campus and operated it as The Monastery of St. Augustine until 2002. It was then sold to the Central States Conference of Seventh-Day Adventists, a part of the Mid-American Union Conference of Seventh-Day Adventists. KCU had no connection to the University of Kansas City, which existed under that name in Kansas City, Missouri, from 1936 to 1963.

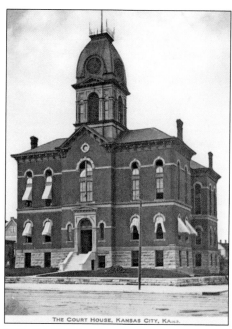

THE COURT HOUSE, KANSAS CITY, KANS.

The second Wyandotte County Courthouse (pictured at left), located at 700 Minnesota Avenue, was officially completed on June 23, 1883, at a cost of $49,760. This courthouse replaced the 329 Nebraska Avenue facility. The second courthouse remained in use for four decades, until the county's burgeoning population growth led to the construction of the present-day courthouse, known as the "Million-Dollar Courthouse," at 710 North Seventh Street Trafficway, in 1927.

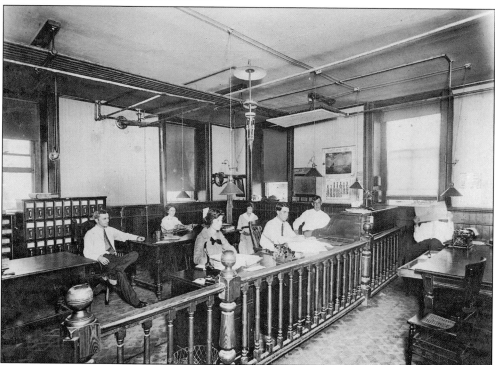

The Wyandotte County Register of Deeds Office, shown here, was located on the first floor of the second county courthouse. The photograph was taken in July 1913. As there was no air-conditioning, this building, as many homes and buildings in the era, were built with high ceilings. This allowed open space for the hot air to rise above the floor and cooler air to circulate just above floor level, where people were working and living. In the winter, some later buildings were equipped with ceiling fans to push the heat down to warm the occupants.

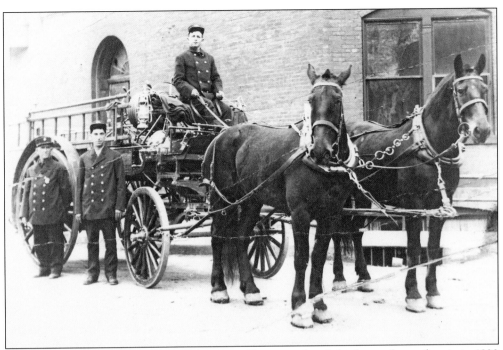

Records indicate that the City of Kansas City, Kansas, ordered this horse-drawn fire rig in 1899 and took delivery of it right after the turn of the century. It took four horses to haul the water tank and the firefighters to the scene of the blaze. The rig was stored in the basement of City Hall, and the horses grazed in a grassy field behind the building.

This Santa Fe steam engine was the workhorse of the yards in the late 1800s. It was not designed to do any long hauls, nor move any heavy loads. It was what is referred to as a "switch engine," meaning it moved two to four cars at a time from one set of tracks to another, routing cars going to different destinations within the Santa Fe system. By the 1980s, the Santa Fe Yards in Kansas City, Kansas, had grown to more than 1,400 acres and were completely computerized.

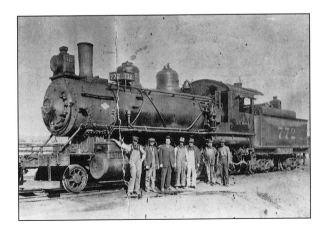

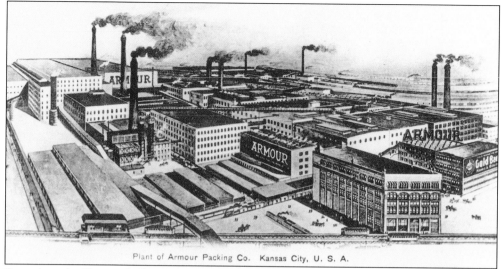

Plant of Armour Packing Co. Kansas City, U. S. A.

Records at the Kansas Collection in the Kansas City, Kansas, Public Library indicate that the city's meatpacking industry was the second largest such industry in the world. Only Chicago was larger in annual number of animals processed. This pioneer packing plant was established in 1868. In 1884, the Armour brothers, H.O., K.B., and C.W., purchased the interests of all previous owners. From 1910 until 1965, the company operated as Armour and Company. The company's operations, pictured here, were on the northeast corner of James Street and Central Avenue. This was just to the south of the site of the first city hall. Armour closed in 1965. United Parcel Service has had a freight shipping and sorting center on the site since 1971.

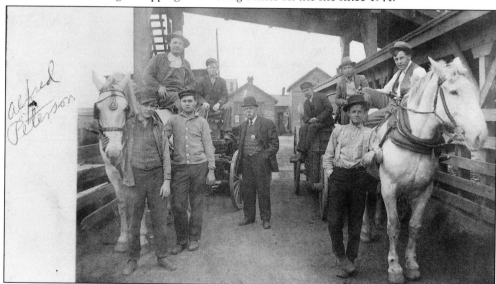

The men in this photograph comprised Armour's hog-driving team. They rounded the animals up in the hog pens when it was time to go "down the chute" to slaughter and processing. The large packinghouse operations had teams who learned to work together in rounding up animals and also understood the idiosyncrasies of managing cattle, hogs, and sheep on the hoof. The name Armour shows up in two other locations in the area. Armour Road is the main street through downtown North Kansas City, Missouri. And the Armour family mansion still stands on Armour Boulevard, an east-west street in midtown Kansas City, Missouri.

18

Morris & Company was among the first meatpackers to get started following Armour. The Kansas State Historical Society lists the following packinghouses established prior to 1910: In the 1880s, Western Dressed Beef; in 1881, Fowler Brothers; in 1884, Morrison Packing House and Kansas City Packing House; in 1885, Allcutt Packing; in 1887, Kingan Packing Company and Swift & Company, which had a four-story cold storage building; in 1892, Shwarzchild and Sulzberg, Wilson and Company, Ruddy Packing Plant, Armourdale American Dressed Beef and Provision Company, and Saint Joe Packing Company. The dates of the following companies are not precisely known: Cochrane and Son, J.C. Bertram, Holmes Packing Plant, August Fruend, Cudahy Packing Company, Baum and Adler, and Jacob Dold and Son.

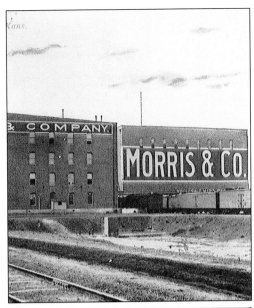

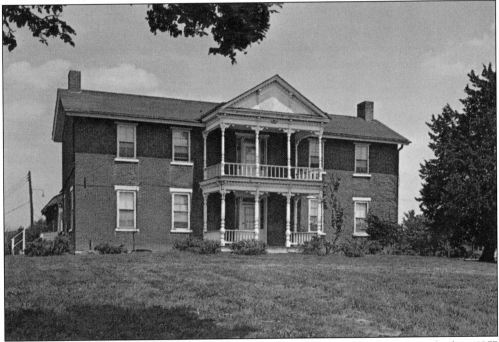

Grinter House, in the 1400 block of South Seventy-eighth Street (at Kaw Drive), was built in 1857 by Moses Grinter, generally considered to have been Wyandotte County's first permanent white settler. Grinter had been hired by the federal government to operate the Army's ferry crossing on the Kansas River to connect Fort Leavenworth to Fort Scott on the south. The Harry Hansen family preserved the property from the 1940s through the 1970s and operated a popular chicken dinner restaurant in the house. The Kansas City, Kansas Junior League then assumed control of the property for nearly three decades. In recent years, the Kansas State Historical Society has assumed complete control of the Grinter property and completed a total stabilization and restoration project to assure its viability for future generations.

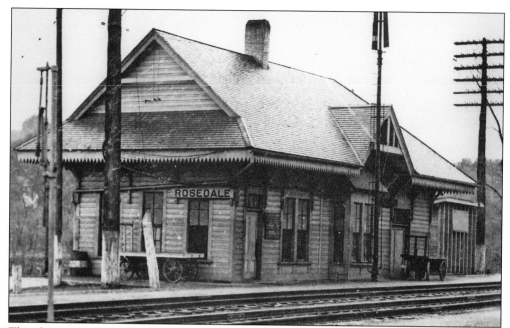

This photograph shows the Rosedale, Kansas, train depot, on the north side of Southwest Boulevard. The lines serving the city were the Missouri-Kansas-Texas, known as the KATY Line, and the Frisco Line. It is not know when the depot was closed down and demolished. The grain elevator the lines served still stands on the northeast corner of Seventh Street and Southwest Boulevard.

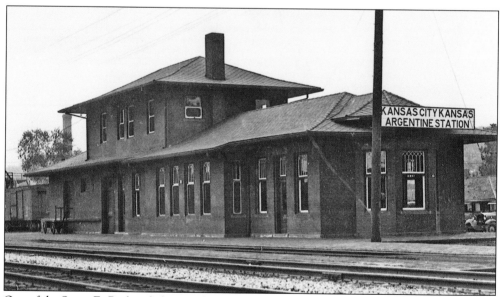

One of the Santa Fe Railroad's busiest depots for both passenger and freight in the late 1800s was located north of present-day Twenty-fourth Street and Strong Avenue in downtown Argentine. Even though Argentine merged into Kansas City, Kansas, in 1910, "Argentine" appeared on Santa Fe timetables into the 1950s, indicating its importance as a shipping stop for the railroad.

In 1894, Dr. Simeon B. Bell, a Rosedale physician, donated land southeast of the intersection of Rainbow Boulevard and Southwest Boulevard in downtown Rosedale to the KU chancellor to serve as a memorial to his late wife, Eleanor Taylor Bell. Bell Memorial Hospital, seen in the photograph, opened on the site in 1905. On June 26, 1924, a new permanent facility was dedicated a half-mile south, at 3901 Rainbow Boulevard. It would be 1947 before the name was officially changed to University of Kansas Medical Center. The buildings shown were razed in 1937.

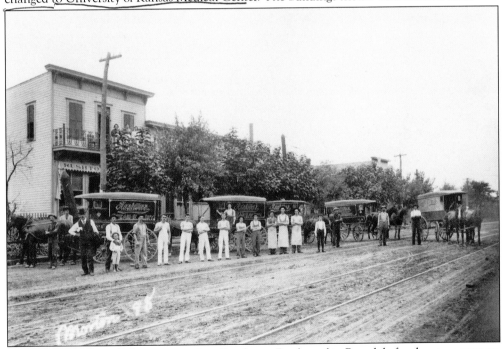

The George Rushton Bakery operated on Southwest Boulevard in Rosedale for close to a century. This late-1800s view reveals how daily deliveries were made—in horse-drawn wagons on unpaved streets. The Rushton name remains visible to this day on the Frank Rushton Elementary School on West Forty-third Avenue. It is now a part of the Kansas City, Kansas, Public School District.

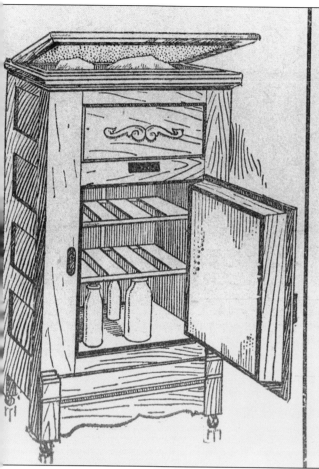

Glanville Furniture Company advertised this "icebox" in 1898. A luxury in the era, the iceman delivered ice to the customer in a horse-drawn wagon. A block of ice was placed in the box over the food storage compartment, and a contraption on the floor below captured water as it slowly melted. The pre-electric icebox allowed people to store fresh food.

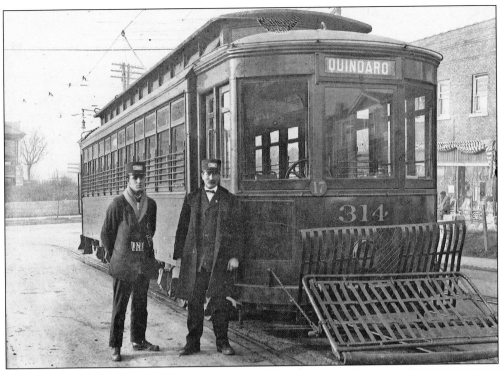

This streetcar traveled along Quindaro Boulevard, the city's northernmost residential-commercial corridor, from downtown to Twenty-seventh Street, in the late 19th century. Note the cowcatcher mounted on the front. There were no cars, but many livestock, horses, and probably a few drunks who did not know that the motorman's loud horn meant "clear the route!"

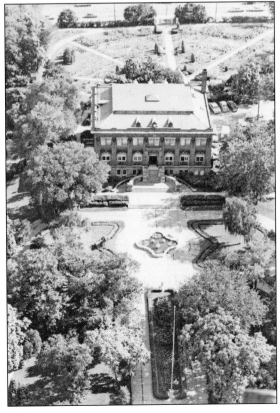

In 1899, the Andrew Carnegie Foundation approved a $100,000 grant for this lavish library and school district headquarters in Huron Park at 625 Minnesota Avenue. It was dedicated in July 1902 and served until a new library was built in 1966. The Municipal Rose Garden was on the rear side of the library and still blooms in downtown's Huron Park.

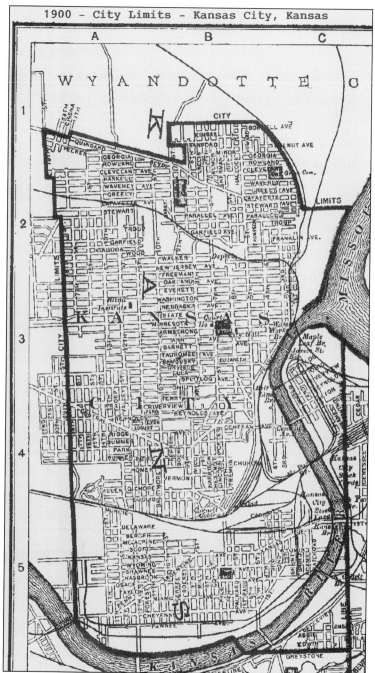

1900 – City Limits – Kansas City, Kansas

The boundaries of the 1900 map of Kansas City, Kansas, reflect the city limits following the 1886 consolidation of the five smaller towns. The single city had a population of 50,000 by 1900. The west city limits ran along Eighteenth Street, north to Quindaro Boulevard, then east to Ninth Street. At that location, Roswell Avenue formed the northern city limits, which then followed a high bluff southeasterly to the Missouri River. The eastern city limits then went due south several miles along the Missouri state line to Greystone Boulevard. The southern boundary followed Greystone west to the Kansas River and then continued along the river back to Eighteenth Street.

Two

THE RAPID GROWTH OF PEOPLE, BUSINESS, AND INDUSTRY

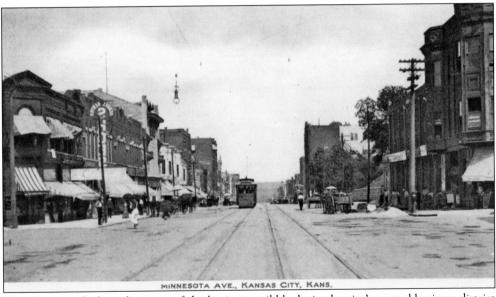

MINNESOTA AVE., KANSAS CITY, KANS.

This photograph shows how one of the busiest retail blocks in the city's central business district appeared just after the turn of the century. The building on the right was People's National Bank, believed to have been the largest bank in Kansas City, Kansas, at that time. It merged with Security State Bank in 1933. Security Bank built an eight-story tower in 1977 on the site of the old federal courthouse, and it remains there today. This 1930s view looks east along the north side of Minnesota Avenue, in the 600 block. On this block, the businesses were S.S. Kresge & Co., The Leader Men's and Women's Clothing, J.C. Penney and Co., Grossman's Men's Wear, B&G Hosiery, Baker's Shoes, Adler's, and numerous other local and national name brand retailers. Helzberg's occupied four addresses along Minnesota Avenue between 1914 and 1971.

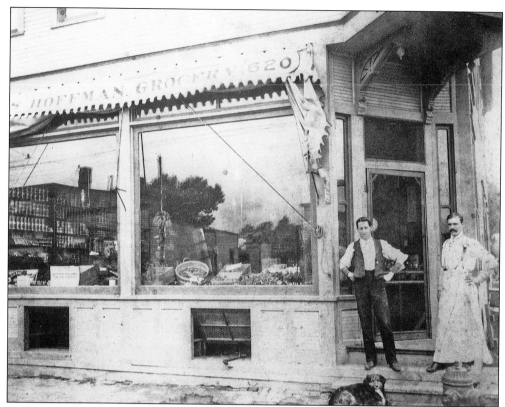

Hoffman Grocery was on the corner of Sixth Street and Tauromee Avenue. This was a typical neighborhood grocery store of the later part of the 19th century and in the years after 1900. No other information was recorded in the archives about the owner or the family associated with this establishment, or the years the store was in business.

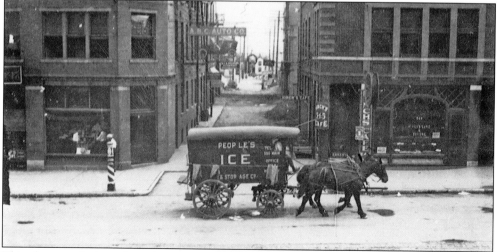

This photograph shows how the iceman used to make daily rounds to those few who owned an icebox to keep fresh food at home. Such companies had daily routes, delivering ice to homes and restaurants. The only kind of daily delivery people may relate to today is that of the letter carrier. A hundred years ago, milk, eggs, and many other products were obtained by this method.

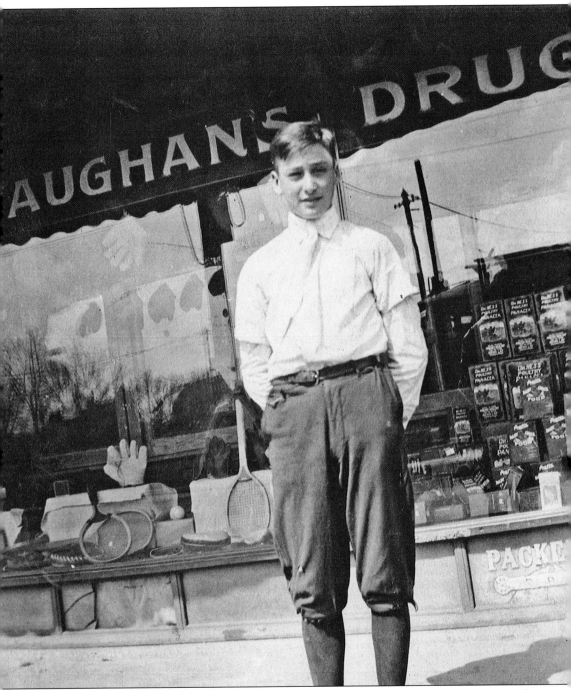

One of W. Lee Vaughan's four sons is shown in front of Vaughan's Drug Store at 1800 Central Avenue about 1920. Vaughan moved to Eighteenth Street and Central Avenue following the Flood of 1903, which washed out the family business on the corner of Eighth Street and Osage Avenue in Armourdale. Note the small size of the baseball glove in the window compared to today's "basket-sized" gloves.

One of the major attractions of Kansas City, Kansas, is nearly lost to history. Carnival Park was bordered by Armstrong Avenue on the north, Tauromee Avenue on the south, and Fourteenth and Sixteenth Streets. The fancy family amusement park operated for only three years. The structures and rides were built out of wood, and two fires in three years—blamed on lightning—resulted in the owners filing for bankruptcy. The Ward High School athletic field now occupies this space.

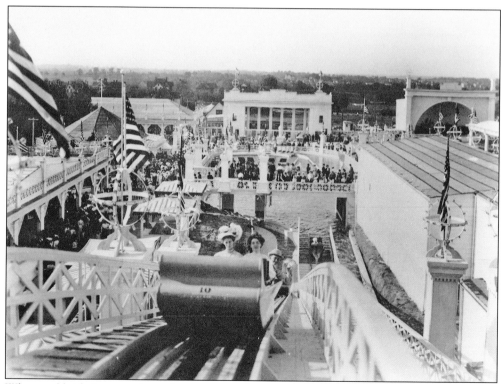

Who would ride in a wooden roller-coaster with no seatbelts? Folks did at Kansas City, Kansas, Carnival Park 100 years ago. Across the United States, such entertainment venues were used daily by people thrilled with such adventures and unaware of the hazards. Over time, these rides proved to be very dangerous and safety regulations were put in place, but this was a "screaming good ride" in 1910!

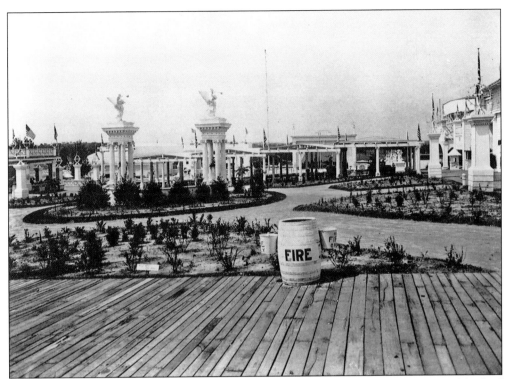

On a hot summer day in Kansas, Carnival Park visitors frequented the concession stand for food and cold drinks. Note the barrel labeled "FIRE"—city fire hydrants did not extend onto the grounds, and people smoked cigars, pipes, and cigarettes. No further explanation of the water barrel should be needed.

Although its life was short, Carnival Parks were a mark of civic pride for the many cities that had them more than a century ago; such parks were a sign of prosperity and prestige. Around the time Carnival Park was in operation, there was Electric Park, a similar amusement park east of downtown Kansas City, Missouri. Two other parks have operated on the Missouri side: Fairland Park was open from the 1940s through the 1970s, and Worlds of Fun has been in business continuously since 1973.

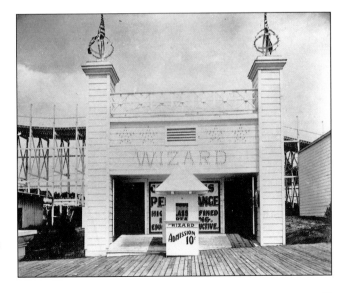

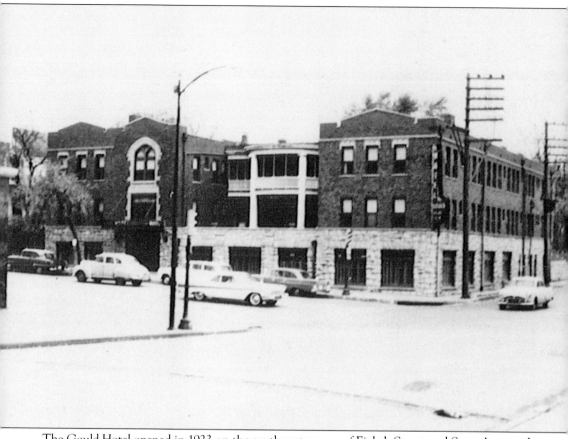

The Gould Hotel opened in 1923 on the southwest corner of Eighth Street and State Avenue. It was the runner-up to the larger, more elegant 1906 Grund Hotel at 800 North Sixth Street. Both hotels were demolished by the Center City Urban Renewal Project in 1970.

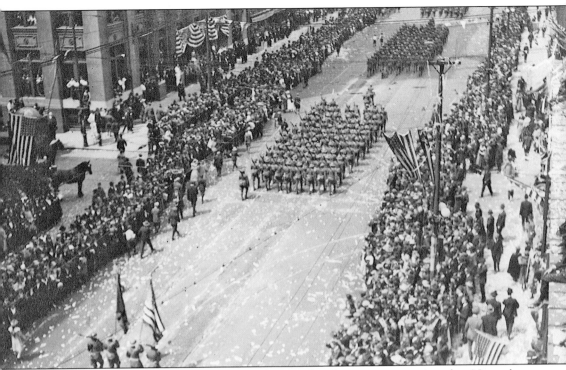

When the soldiers returned home from World War I after the armistice was signed on November 11, 1918, virtually every city in the United States celebrated with a victory parade. Kansas City, Kansas, was no exception. In this photograph, troops are marching down Minnesota Avenue, with the sidewalks packed on both sides with thankful and well-wishing citizens.

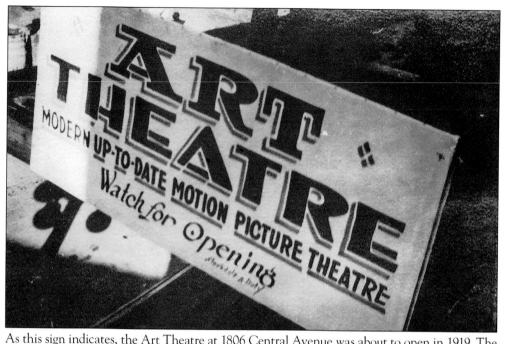

As this sign indicates, the Art Theatre at 1806 Central Avenue was about to open in 1919. The popular neighborhood theater was sold in 1936 and it became the Jayhawk Theater. The Jayhawk operated until 1969, when it was demolished to make way for an expansion of the Chas Ball Food Store. The Art Theatre was one of four neighborhood movie theaters that W. Lee Vaughan operated in Kansas City, Kansas.

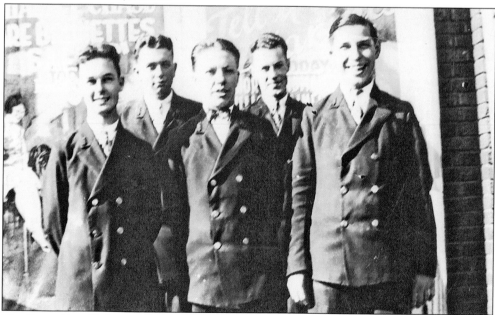

The five unidentified young men in this photograph are going to see a silent film at the new Art Theatre. As shown by their dress, going to the theater, even if it was in the neighborhood, was a big event in those days. There were few cars, no radio, and no television . . . to say nothing of the explosion in electronics of the past decade.

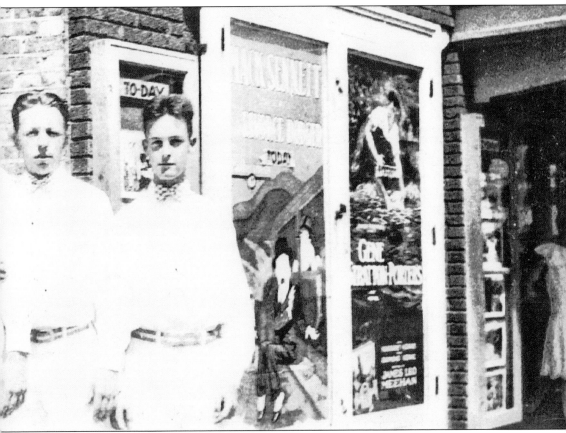

Art Theatre film features (all silent movies) awaiting these young men included *The Keeper of the Bees* (by author Gene Stratton Porter), *Are Brunettes Safe?* (featuring Charley Chase), and, between features, slapstick comedies by the famed Mack Sennett. An additional draw of neighborhood movie houses in the 1920s and 1930s was that they were the first businesses to be completely air-conditioned.

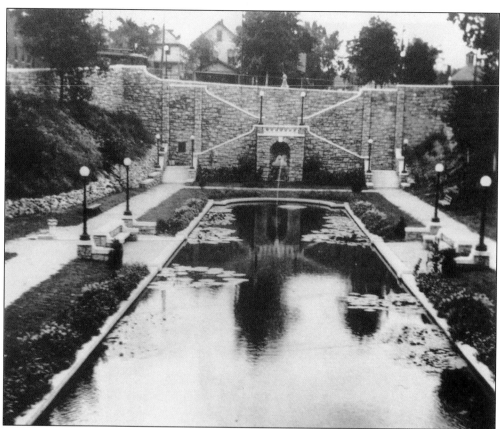

A sunken garden, complete with a bubbling fountain, filled most of a downtown city block east of Eleventh Street between State Avenue and Minnesota Avenue in the 1920s. The colorful, seasonal flowers and plants and extensive limestone crafting was worthy of the Country Club Plaza in that era. High costs of maintaining the scenic site during the Depression brought an end to it. Waterway Park covered parts of 11 city blocks from Washington Boulevard south to Grandview Boulevard. Almost a century after the Kansas City, Kansas, sunken garden showpiece was opened, the bandstand is the only element still usable. It is on the east side of Big Eleven Lake at Eleventh Street and State Avenue. The cast-iron light stands were originally gas. Each evening, the lightman came to the park to turn on natural gas jets to light the evening's events. Big Eleven Lake covers approximately four square blocks and for nearly 100 years has provided a peaceful respite in downtown Kansas City, Kansas. The lake formed the north end of the once massive Waterway Park along the west side of downtown. The native limestone rock around the shore was put in as a WPA project during the Depression.

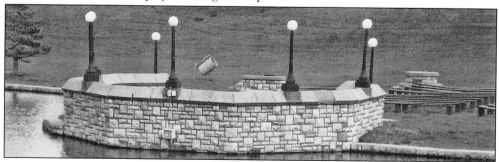

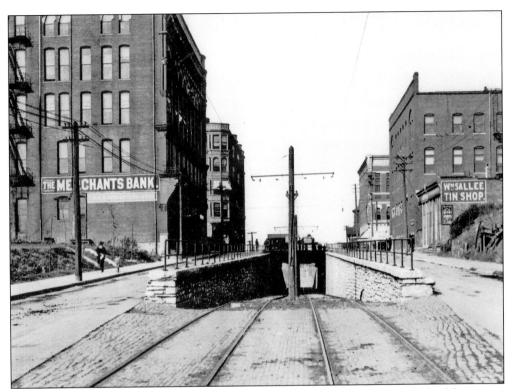

At the turn of the last century, Sixth Street and Minnesota Avenue was the hub of downtown Kansas City, Kansas, retail and commercial activity. This view facing north shows the north–south tunnel for streetcars that ran under Minnesota Avenue (east–west) to State Avenue to help relieve congestion. From left to right are the Portsmouth Building (note the Merchants Bank sign for the first-floor occupant), the Husted Building, the IOOF Lodge Building, and the Home State Bank Building. The tunnel was filled in about 1906, as cars began to increase in volume and the tunnel caused more traffic congestion than it relieved.

The five-story Portsmouth Building at 601 Minnesota Avenue was completed in 1892 and was considered the prestige address for the city's professionals in that era. Newer office buildings (the Huron Building and the Brotherhood Building) opened as the center of the central business district moved farther west. The Portsmouth Building was demolished in 1924. This image faces southwest from the IOOF Lodge Building.

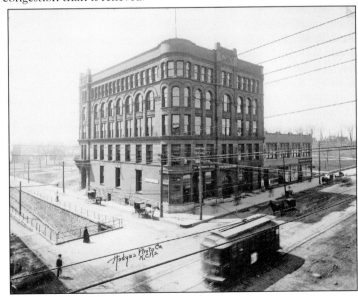

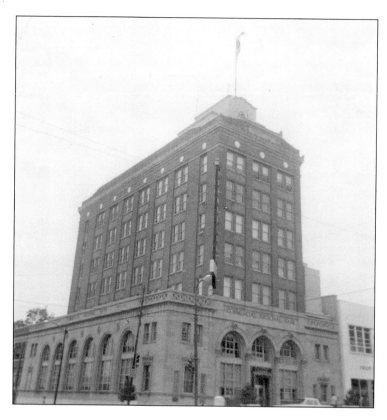

Commercial National Bank purchased the site of the old Portsmouth Building and constructed a seven-story tower at 601 Minnesota Avenue. It opened in 1925. The outside of the building was updated with a plastic shell in 1968. In 1984, United Missouri Bank purchased Commercial, and it became UMB-Kansas.

One of the most attention-getting monuments in Kansas City, Kansas, is the Rosedale World War I Memorial Arch, at Thirty-sixth Street and Springfield Avenue in Mount Marty Park. It is a scaled-down replica of the famed Arc de Triomphe in Paris. The citizens of Rosedale dedicated the arch in memory of the city's soldiers who were killed in World War I. It is adorned with an American flag and is always floodlighted.

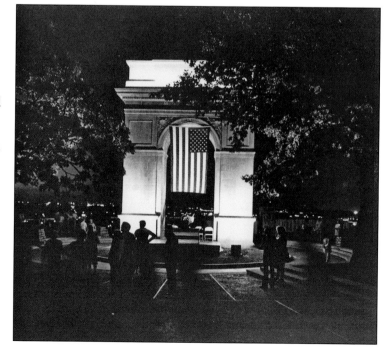

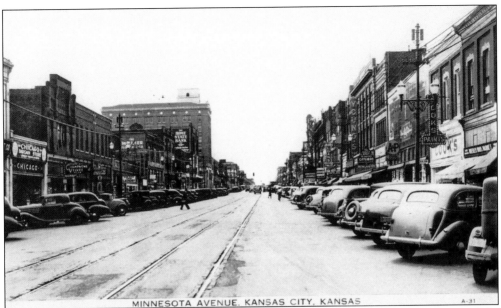

MINNESOTA AVENUE, KANSAS CITY, KANSAS A-31

This view looks west down the 500 block of Minnesota Avenue in the 1930s. Some of the businesses along The Avenue were Butler Music Company, Western Auto, Young's Department Store, Jenkins Music Company, the Electric Theater, Feingold's Furniture, DeAngelo's Italian Restaurant, Ken's Blue Willow Café, Cook's Paints, Gateway Sporting Goods, the Chocolate Shop, Hyman's Bakery, and DeGoler's Pharmacy.

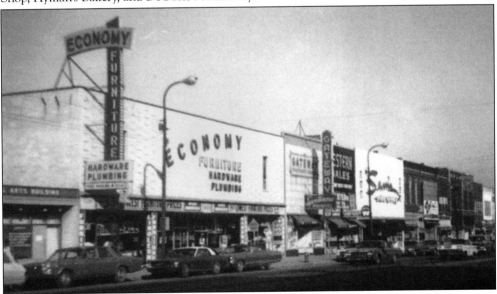

Economy Furniture, Hardware, and Plumbing on the north side of the 500 block of Minnesota Avenue is pictured about 1970. Lewis Deutch started the family business in the 1920s at 430 Minnesota. It moved to 441 Minnesota and remained there for some 35 years before the Gateway Urban Renewal project resulted in a relocation to 514 Minnesota, in this view. Deutch was killed during an armed robbery. His son Al then ran the business until the end of World War II when he was joined by his two brothers, Moe and Harry Deutch. The family closed the business a short time after this photograph was taken after some 50 years of business in downtown Kansas City, Kansas.

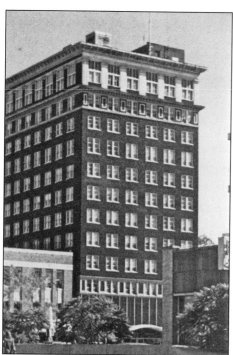

The 12-story Huron Office Building opened in 1924 as the Elk's Lodge at 905 North Seventh Street. Not-for-profits often built high-rise office buildings and then used the revenue from leasing tenants to fund benevolent projects in the city. Between 1924 and 1969, this was the tallest building in Kansas—a state not known for skyscrapers. When the 50-foot flagpole existed, the structure measured 198 feet in total height. This was the prestige office site following the Portsmouth Building. The Huron Building was demolished in 1999 following years of neglect.

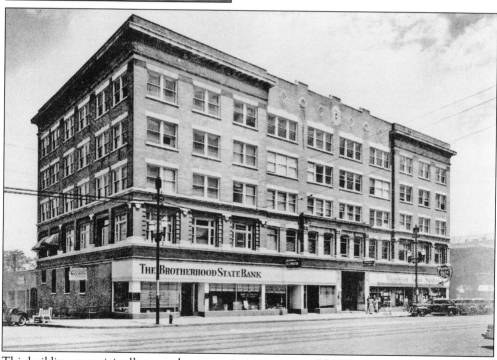

This building was originally erected as a two-story structure at 754 Minnesota Avenue in 1916. At the time, that was sufficient office space in downtown Kansas City, Kansas. When the International Brotherhood of Boilermakers purchased it in 1924, the upper three stories were added and it was renamed the Brotherhood State Bank Building. Many prominent doctors and lawyers were located in this building. The Boilermaker's Union still uses all five levels today.

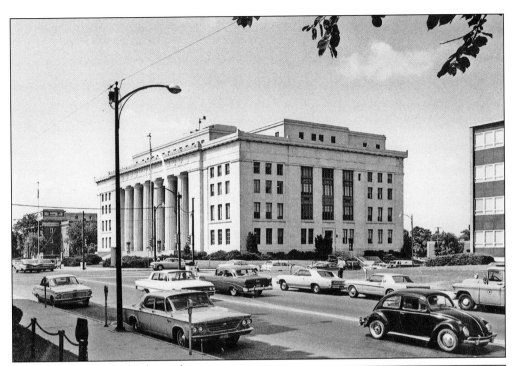

Wyandotte County's third courthouse, at 710 North Seventh Street Trafficway, was completed in 1927. The six-story building was dubbed the "Million-Dollar Courthouse" because of its impressive edifice featuring six columns. The architectural firm of Wight & Wight designed it to resemble the Nelson-Atkins Museum of Art in Kansas City, Missouri.

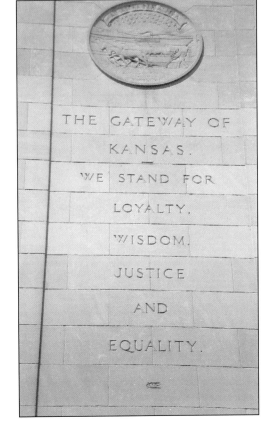

THE GATEWAY OF KANSAS. WE STAND FOR LOYALTY, WISDOM, JUSTICE AND EQUALITY.

On the northeast corner of the Wyandotte County Courthouse is a proclamation that perhaps few people have noticed or read in over 80 years. It speaks to the pioneer heritage of Kansas as a free state.

The Rosedale State Bank is pictured at 700 Southwest Boulevard. In 1962, the bank erected a new headquarters building in the 3400 block of Rainbow Boulevard with a connected drive-in facility. The Southwest Boulevard location did not have available open space to add drive-up facilities. The new location also added a trust department.

The lobby and teller cages of the Rosedale State Bank are shown in the 1950s. This building was not air-conditioned and lacked space for the coming credit card services and for a trust department that management wanted to add; the site could not accommodate the additional services called for in a new era of banking.

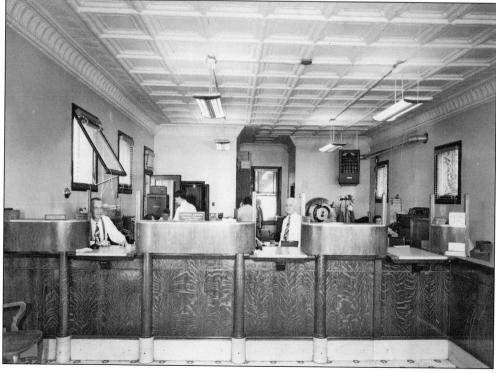

Three

THE CITY'S FIRST MAJOR DECADES OF DEVELOPMENT

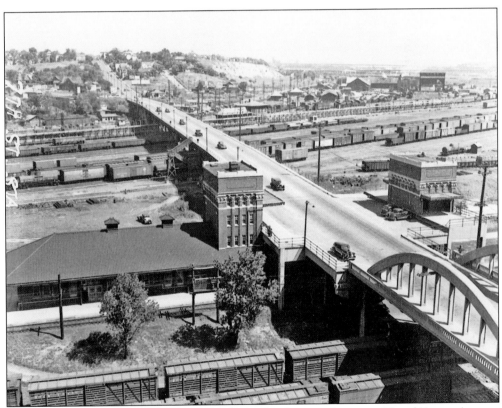

The Seventh Street railroad station was on the viaduct between Interstate 70 and Kansas Avenue. Union Pacific operated this facility and leased space to the now-defunct Rock Island Railroad. The dark brown brick and white trim are typical of Romanesque architecture. The station was built sometime around 1920. The Argentine and Rosedale train depots are also pictured in this book. There are no photographs, nor records, of the old Missouri Pacific Station, which was at Second Street and Washington Boulevard on the edge of Fairfax and had brick of the same color, but a roof that was gabled and made of red tile.

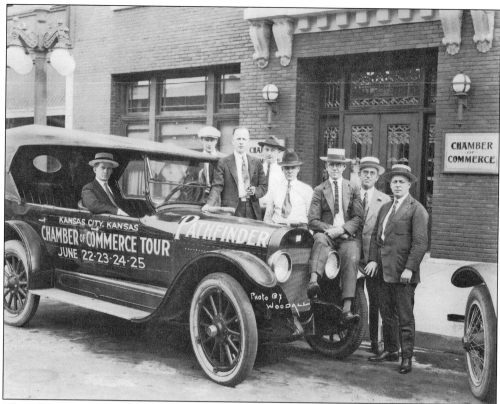

These businessmen show how a chamber of commerce membership drive was conducted in the festive atmosphere of a decorated car, pictured at the chamber's headquarters at 727 Minnesota Avenue. The building, still occupied by the chamber, was undergoing a complete renovation in 2012. It is a designated historic building, so the work must meet specific requirements. It was built as an Eagles' Lodge in 1902 and has a fireplace in each corner of the basement for heat. From the 1910s through about 1950, the chamber offered full menu lunch service on the lower level.

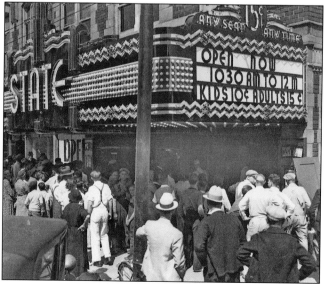

The State Theater was located on the north side of the 700 block of Minnesota Avenue. Four theaters operated in the heart of downtown: the State, The Avenue (in the 800 block), the Granada (at 1029), and the Electric at (546 Minnesota Avenue). The only one in (moderately) restored condition today is the Granada Theater.

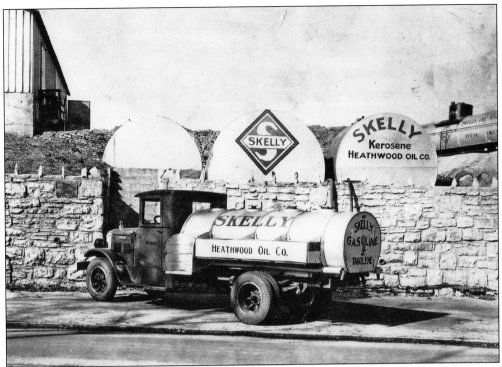

The fourth generation of the Shondell family is now working at the Heathwood Oil Company, which has been at 2011 North Tenth Street in Kansas City, Kansas, since its founding in 1924. What younger readers do not know is that, prior to the Korean War, oil was used to run furnaces to heat many residences and businesses. Many properties had tanks in the basement. Heathwood serviced that market for many years by delivering home heating oil to thousands of area homes and businesses. If a homeowner dipped a yardstick into the tank and it came up dry, it was time to call Heathwood.

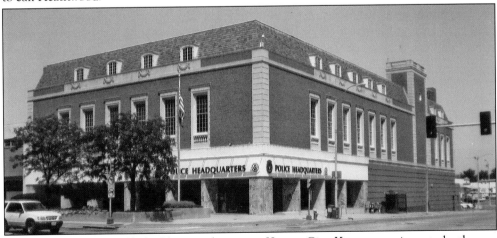

One of the most venerable buildings in downtown Kansas City, Kansas, continues to be the one that was built for Montgomery Ward in 1938. The stylish four-story structure housed the Board of Public Utilities (BPU) for many years and now is headquarters for the Kansas City, Kansas, Police Department. The second Wyandotte County Courthouse stood on the site between 1883 and 1935.

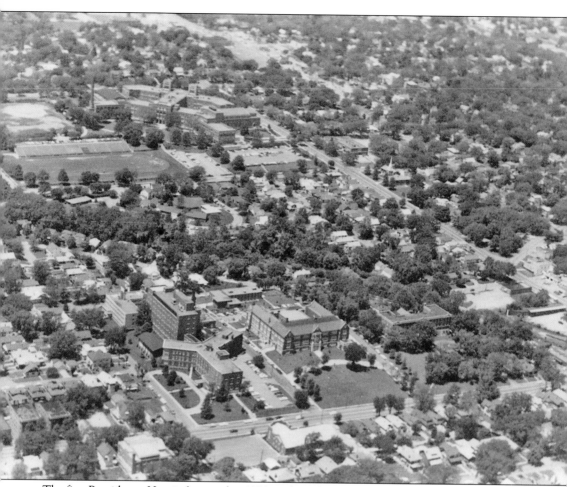

The first Providence Hospital opened in 1920 in the Y-shaped building (at lower left) at Eighteenth Street and Tauromee Avenue. In 1958, the seven-story high-rise behind the original building added 200 beds, a new chapel, and other new medical service capabilities. Providence merged with St. Margaret's Hospital in the early 1970s to form Providence–St. Margaret Health Center, affiliated with the Archdiocese of Kansas City in Kansas. In 1976, the merged hospitals moved to a high-tech, state-of-the-art facility at 8929 Parallel Parkway.

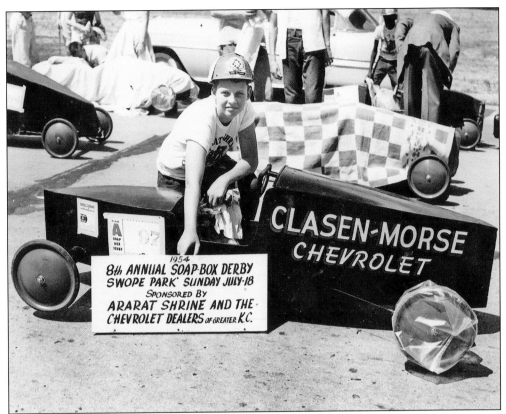

The annual soap box derby for teenage boys was a major spring event in Kansas City, Kansas. This car was sponsored by Clasen-Morse Chevrolet. The preliminary races were held in the surrounding cities, and the final completion took place at Swope Park in Kansas City, Missouri.

The competition between the kids was intense because there were a variety of prizes for the winners in various categories. The George S. Baker for Sheriff Committee sponsored this car. These events attracted teenage boys in the years before they were old enough to get a driver's license. Each boy had to build his own car. Rules were strictly enforced, and if word got out that an entrant had too much adult assistance, he was quickly disqualified from the race.

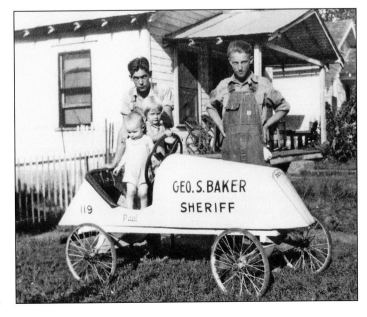

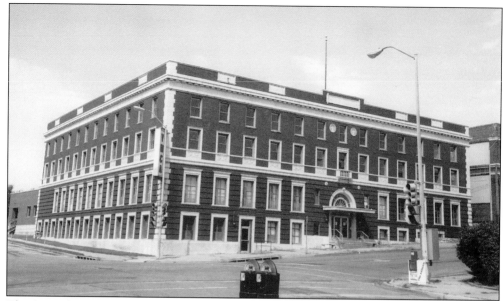

The Central Branch of the Kansas City, Kansas, YMCA is at 900 North Eighth Street. This red-tiled building, framed in white tile, presents a bold image to those who pass by. The lower levels were completed in 1916. The top two floor dormitories were completed in the late 1920s.

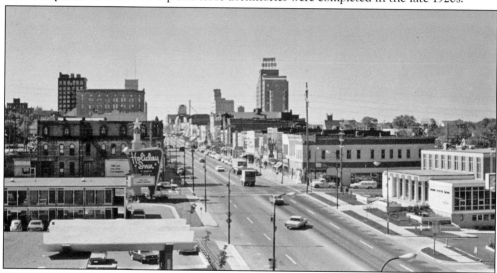

This photograph looks west four blocks along Minnesota Avenue from Fourth Street. The flashy Holiday Inn neon sign, at left center, went up when the 225-room motel opened in 1963 on property cleared as part of the Gateway Urban Renewal Project. It replaced a dilapidated block of old hotels, pawnshops, and furniture stores. The Region VII offices of the US Environmental Protection Agency replaced the Holiday Inn in 1993 in a seven-story structure. The building in the lower right corner was completed in 1964 for Home State Bank, which had been a block west since 1902. In recent years, the bank operated as Bank Midwest. Previously, the Wyandotte Office building was at that location. In 1942, it was demolished to make way for Sam's Loan Office, which was taken down by the Gateway project in 1958. The Children's Campus of Kansas City opened at the site in 2009 to serve inner-city, impoverished children. The intersection at the center of the photograph is Fifth Street and Minnesota Avenue.

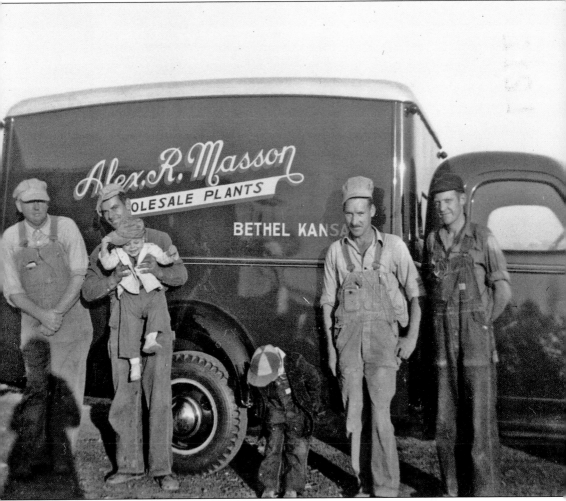

Alex R. Masson Wholesale Plants was in business in Kansas City, Kansas, for over 100 years. Three generations operated the business at 1700 North Eighty-second Street from 1919 to 2003. The reference to "Bethel Kansas" on the side of the 1939 delivery truck was a postal delivery identification used before city annexation.

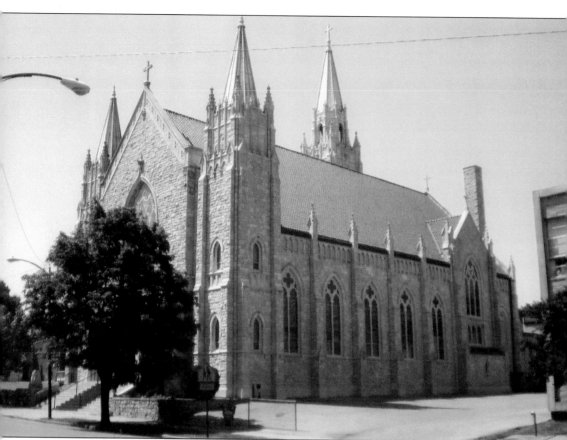

The 140-foot bell tower of St. Peter's Cathedral at 414 North Fourteenth Street (Grandview Boulevard) in Kansas City, Kansas, dominates the skyline. The church, nestled in a quiet residential neighborhood, was completed in 1927. The Gothic-style limestone cathedral is highlighted by a red-tiled roof. Since 1948, the cathedral has served the 12 northeast Kansas counties that make up the Archdiocese of Kansas City in Kansas.

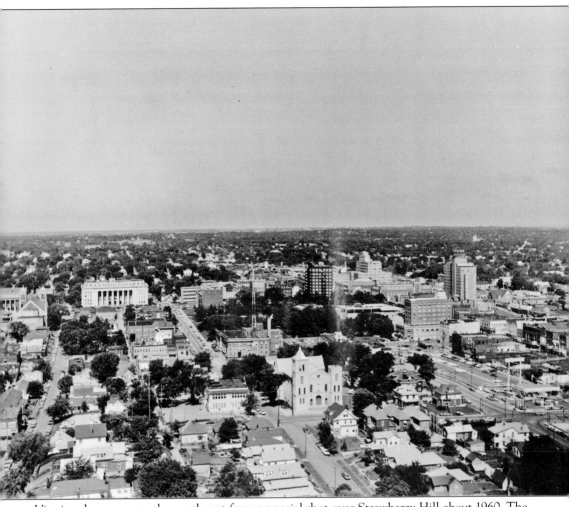

Viewing downtown to the northwest from an aerial shot over Strawberry Hill about 1960. The 1927 "Million Dollar Courthouse" dominates at left center. St. Mary's Catholic Church is shown lower center on the northwest corner of Fifth Street and Ann Avenue. The parish was organized in 1858. The church building shown here was built in 1890. It has been abandoned since St. Mary's merged with St. Anthony's Catholic Church, shown with two bell towers just left of the courthouse. Right-center (clockwise) the high-rise towers are the Huron Building (built in 1924; demolished in 1999); The New Brotherhood Building (1949); the Town House Hotel, now known as Crosslines Senior Apartments (1951); and Commercial National Bank (1925), now UMB-Kansas.

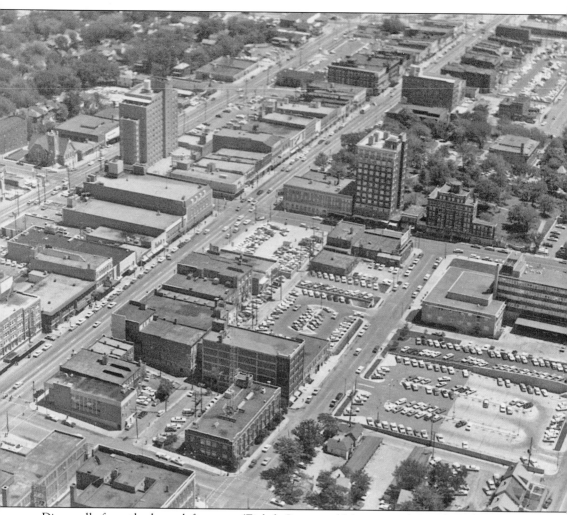

Diagonally from the lower left corner (Eighth Street and Minnesota Avenue) to the top right center (Fifth Street and Minnesota) of this aerial photograph, the three dominant retail blocks of downtown are shown about 1962. Minnesota is an east-west street and the stores on the north side always dominated because the winter ice and snow melted faster and cleared more easily from the sunshine. The main streets of most Midwest downtowns are north–south so that, between morning and afternoon, there is approximately an equal amount of sun in the winter and shade on the hot, humid summer days. Streets in Kansas City, Kansas, are numbered west from the junction of the Missouri and Kansas Rivers.

Four

THE GREAT DEPRESSION AND THE DUST BOWL TAKE A TOLL

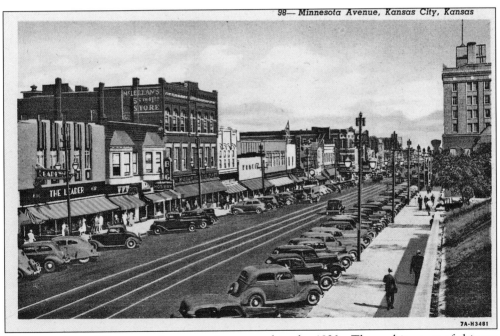

98— Minnesota Avenue, Kansas City, Kansas

7A-H3481

This view shows Minnesota Avenue as it appeared in the 1930s. The architecture of this era prior to air-conditioning included lots of bay windows on the second floors to capture any passing breezes. Generally, the first buildings that began using air-conditioning were movie theaters.

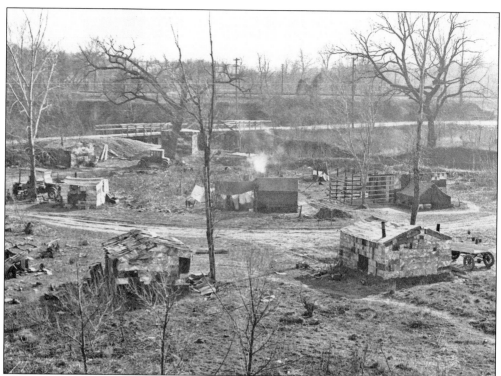

The Great Depression is generally considered to have hit rock bottom in 1933. This may explain why many people, upon losing their jobs, their homes, even everything, moved into shantytowns that were called "Hoovervilles," so named because the Depression began during the presidency of Herbert C. Hoover.

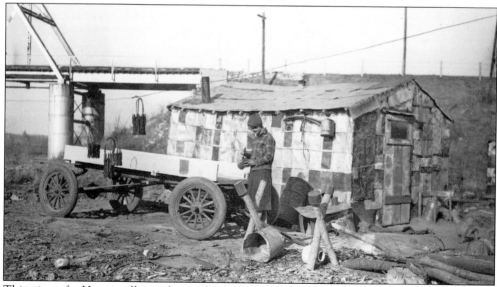

This view of a Hooverville resident is likely from the same collection as the image at the top of the page. The largest gatherings of Hoovervilles were along the Kaw River bottoms south of Kansas Highway 32. Many social "safety nets" were created during the Roosevelt administration of the 1930s with the aim of preventing a similar crisis.

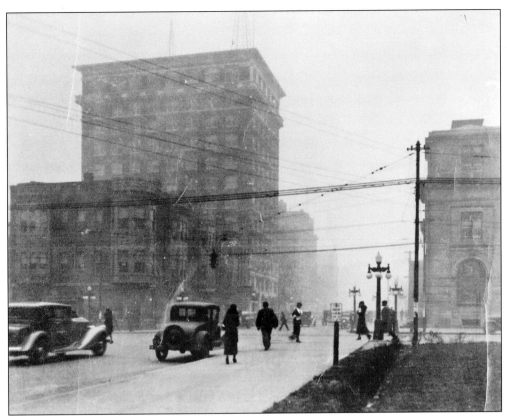

Along with the Depression, the dust bowl years are one of the most memorable aspects of the 1930s in Kansas. This view, looking south on Seventh Street from Minnesota Avenue, illustrates how wind-blown dust often filled the air, day in and day out, while temperatures soared above 100 degrees. The Huron Building (at left), a half-block away from the photographer, is barely visible.

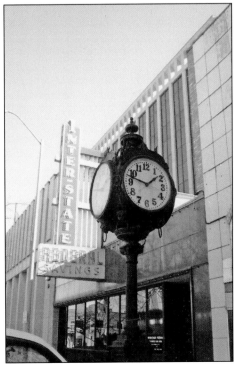

The Winkler's Jewelry Store clock was made by the Seth Thomas Clock Company and has been at Winkler's several addresses along Minnesota Avenue since 1914. The Neoclassical design is emblematic of the City Beautiful movement that grew out of the Chicago World's Fair of 1893. It has been at 717 Minnesota since the mid-1950s. The Inter-State Federal Savings neon sign behind the clock is a survivor from the early 1950s. It is well maintained and burns brightly every night.

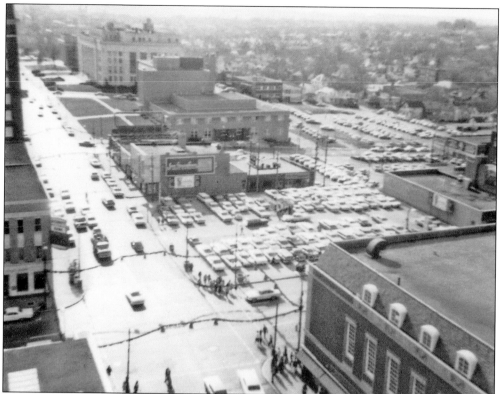

A 1965 view from the west penthouse on the 15th floor of the former Town House Hotel shows the west side of the Seventh Street Trafficway from the upper left corner north to the 1927 Courthouse, the 1958 Federal Courthouse, the parking lot that replaced the 1902 Federal Courthouse, and to the 1938 Montgomery Ward's store at the lower right during the Christmas shopping season. Lots of shoppers/pedestrians and Christmas decorations are in view. This was arguably the last hurrah of downtown's retail dominance. A year later, Sears moved out to become the anchor store at Tower Plaza. When Indian Springs regional mall opened in 1971, the floodgates opened for the departure of Ward's and Penney's to the climate-controlled, glitzy center.

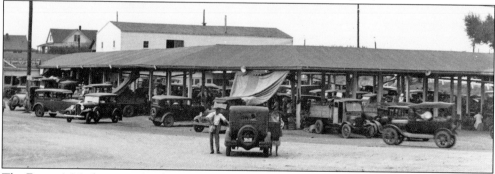

The Farmer's Market was a landmark on the northeast corner of Thirty-eighth Street and State Avenue, until Tower Plaza Shopping Center replaced it in 1964. The value of the land became too high to use as a market; Sears department store became the shopping center's main anchor. During the market's existence, truck farmers from the western sections of Wyandotte County (outside of the city limits) would bring their produce on Saturdays. People who wanted fresh-from-the-farm vegetables and other garden goodies filled the isles on Fridays and Saturdays.

The Kansas City, Kansas, Parks Department operated a zoo. Although little detailed information has been discovered about it, records do indicate that it was located in the area around Nineteenth Street and Wood Avenue, along present-day Jersey Creek. At its peak, the zoo was comparable to zoos in mid-sized cities, but it never had the variety of animals and extent of displays as, say, Kansas City, Missouri's, Swope Park Zoo has had for more than a century. Cutbacks in city funding during the Depression are widely believed to have forced the closing of the zoo.

Pictured in the animal shelter at Chelsea Park is a bear (left) in a cage, and a camel, with a smaller animal (Shetland pony?) standing in front with a monkey on the back of the smaller animal.

Chelsea Park was zoo's site

(This is the 41st in a series of "then and now" articles on places and things of interest in Kansas City, Kan., compiled by area historian Margaret Landis in observance of the 100th birthday of KCK this year. Much of the information has appeared in past editions of The Kansan.)

In the past two "then and now" articles we explored the history of old Chelsea Park — with the present Westheight Park the last remaining vestige of Chelsea — and how it and the development of other parks evolved through the promotion

made a fine lake fed by cool springs of water. On the south bank of the lake is an elegant summer theater which will be the attraction during the summer nights with music by the Standard Opera Company.

"On the north bank of the lake is Mount Vesuvius. This is a building constructed so as to resemble the celebrated volcano with the City of Naples at the foot. On the Fourth of July and twice a week during the summer a giant display of fire works, representing the volcano in a state of eruption with lava flowing down will be exhibited. . . ."

FIFTY-SEVENTH

ANNUAL REPORT

OF THE

Woman's

Christian Temperance

Union

OF THE STATE OF KANSAS

Organized 1879.　　Incorporated 1885

Minutes, Reports, County and State Directories, etc.

Edited by the Recording Secretary
MRS. LEAH THOMAS

October 1, 2, 3, 4, 1935
KANSAS CITY, KANSAS

Anyone who knows Kansas history will not be surprised to see this 1935 booklet of the Women's Christian Temperance Union of Kansas. These were the years just after Prohibition ended, and one of the temperance movement's leaders, Carrie Nation, was from Kansas. Even long after the end of Prohibition, Kansas continued to be a dry state. Most famously, in the 1970s, then–attorney general Vern Miller boarded an Amtrak train and charged various Amtrak employees with "serving liquor in Kansas." The lack of the availability of liquor cost Johnson, Wyandotte, and Leavenworth Counties millions of dollars in lost business because restaurants in Kansas City, Missouri, did not have that hindrance. In 1986, Kansas voters approved an amendment to the state constitution to permit sales of liquor by the drink.

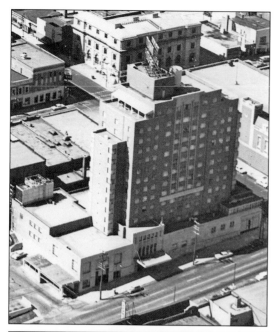

This 1962 photograph focuses on Seventh Street and Minnesota Avenue (left) and Seventh Street and State Avenue (right). The Town House Hotel (now Crosslines Senior Apartments) at 1017 North Seventh Street Trafficway dominates. At the top of the hotel's tower, a recessed awning is visible below the rooftop neon sign. There were four penthouses on the 15th floor that were considered at the time to be the most opulent high-rise homes in Kansas City, Kansas. They were occupied by M.L. (Maurice) Breidenthal Sr., chairman of the board of Security National Bank; Al Lew, Town House general manager; and one of the Katz brothers who cofounded the Katz Drug Store chain in 1914. The fourth penthouse was held for VIPs. Over the years, many presidents, senators, and governors used it while at hotel events.

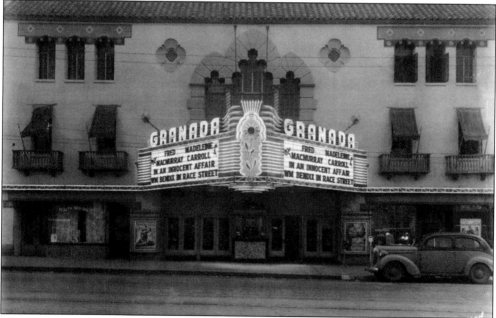

The Granada Theater opened at 1019 Minnesota Avenue in 1929. Noted theater architects of the era the Boller Brothers designed the 1,200-seat palace in a Spanish Colonial Revival style. Its most unique feature is a domed ceiling that gives patrons the feeling that they are sitting in an outdoor courtyard at night. The dome is painted dark blue to create the appearance of a dark night sky. Small electric lights were built into the ceiling to represent twinkling stars, as cloud machines along the theater side walls project drifting clouds across the impression of the night sky. In 1994, the Granada served as the set for Kansas City, Missouri, native movie producer/director Robert Altman's production of the film *Kansas City*. The Granada is on city, state, and national historic registries.

Geographically, Turner was a notable unincorporated area south and east of the Kaw River and west of Argentine. Kansas City, Kansas, annexed it in the mid-1960s. The Turner School District is independent and maintains a distinct identity and sense of community. In the 1930s, the downtown district, seen in this photograph, was along Fifty-fifth Street, which remains a vital corridor from Kansas Avenue south to the Johnson County line.

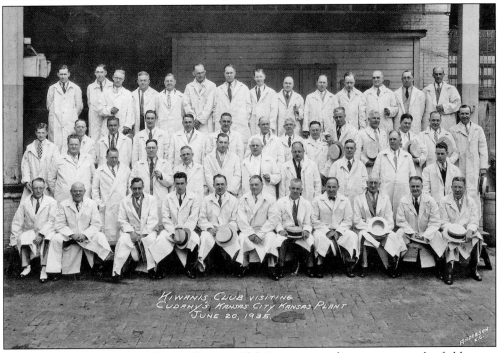

The Downtown Kansas City, Kansas Kiwanis Club, Inc., at one of its meetings, took a field trip to and had lunch at one of the city's many packinghouses. (A packinghouse is a facility where cows, hogs, and sheep are taken to be prepared to be sold in grocery stores for human consumption.) Service clubs often took field trips to the city's vast industries. Usually, a member of the club who worked at a particular industry arranged for the visit. It was good public relations for both the clubs and the plants.

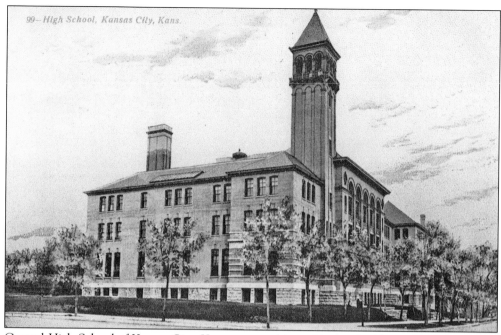

Central High School of Kansas City, Kansas, moved into this new building at 900 Minnesota Avenue in 1899. In 1928, the name was changed to Wyandotte High School. A fire of undetermined origin destroyed the building in March 1934. No one was injured. Months of serious investigation never revealed the cause nor indicated that the fire was suspicious.

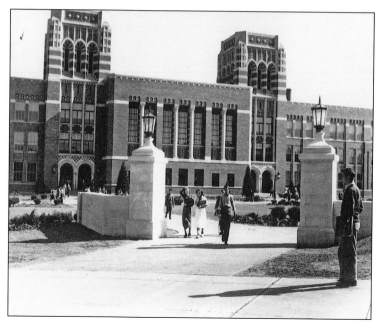

A new Wyandotte High School opened in the fall of 1937 on 25 acres of the former Westheight Golf course at 2500 Minnesota Avenue. It was built for a student capacity of 2,800, making it one of the largest high schools in Kansas. This still-glamorous building is on the city, state, and federal historic registers. Approximately $20 million was spent on a complete renovation in the 1990s.

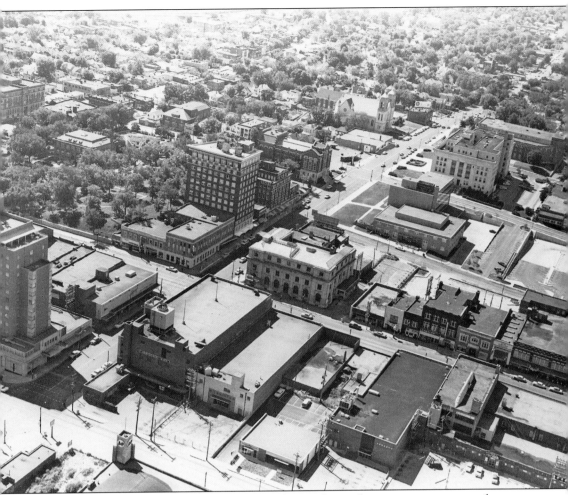

This photograph can be dated between 1958 and 1961, due to the presence, at center, of the 1902 US Courthouse and the Federal Building at 701 Minnesota Avenue. Center right is the new federal courthouse, which opened in 1958. The 1902 courthouse is now the location of the eight-story Security Bank Tower. When the 1958 courthouse was replaced, the building was sold to Wyandotte County, to house the Juvenile Courts Division.

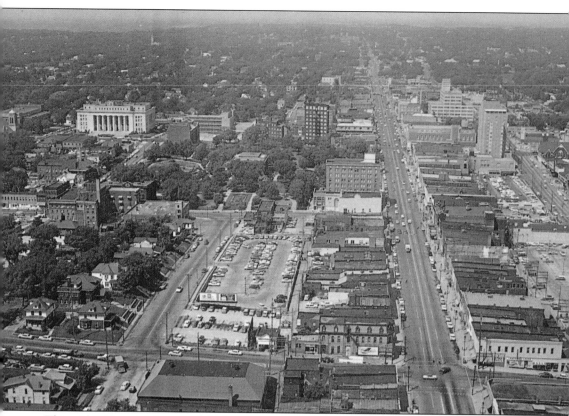

This mid-1950s aerial photograph looks west over downtown Kansas City, Kansas, from approximately the junction of the Missouri and Kansas Rivers at First Street. Minnesota Avenue is the wide street just right of center in this photograph. The dominant high-rise buildings shown upper center are the courthouse, the Huron Office Building, and the Town House Hotel. The accurate dating of this photograph is possible because of the row of buildings at the bottom (east side of Fifth Street) beginning to be demolished for the Gateway Urban Renewal Project about 1958.

Five

THE CITY PLAYS A HUGE ROLE IN WINNING THE WAR

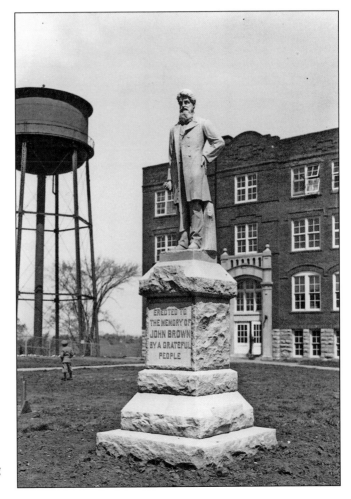

Western University (northwest of the present-day intersection of Twenty-seventh Street and Sewell Avenue) was a historically black college in Quindaro, Kansas, following the Civil War. It was the first all-black university west of the Mississippi and the only one in Kansas. Eva Jessye is believed to have been its most noted graduate. She formed her own choir and performed with the legendary George Gershwin in New York City. The Great Depression had seriously weakened the university, and it was forced to close in 1943. This statue of abolitionist John Brown is the only marker still standing on the campus grounds.

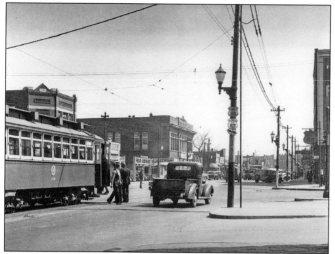

This 1940s photograph is looking east on Kansas Avenue from Seventh Street Trafficway in Armourdale. Kansas Avenue continues to be a commercial, residential, and industrial corridor vital to the city's economy. Near the state line, Epic, Inc., a computer chip provider, occupies one of the sites where Wilson Packing once stood. On the west end of the district, Colgate-Palmolive continues to manufacture soap products in the building opened in 1905.

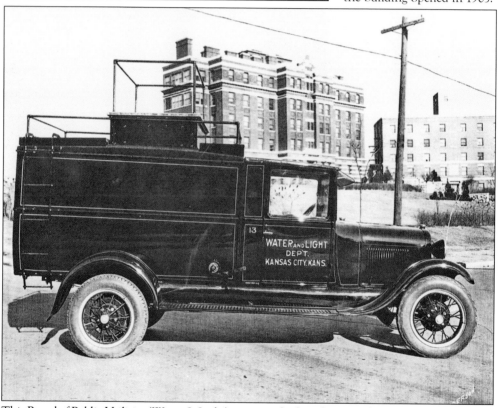

This Board of Public Utilities (Water & Light) service vehicle is shown in front of Bethany Hospital at Twelfth Street and Central Avenue. Bethany was founded by the Methodist Church in 1892. The first permanent building (center) opened in 1905 at 51 North Twelfth Street. The nursing facility (right) opened in 1911. A west wing was added in 1956–1957, and a huge south wing was constructed in front of the original building in 1975–1977. Bethany closed due to bankruptcy in 2001. The site was cleared and is now occupied by multifamily residential structures. The Veteran's Administration Health Care System operates a community-based outpatient clinic at the 51 North Twelfth Street address, but it has no relationship to the original Bethany Medical Center.

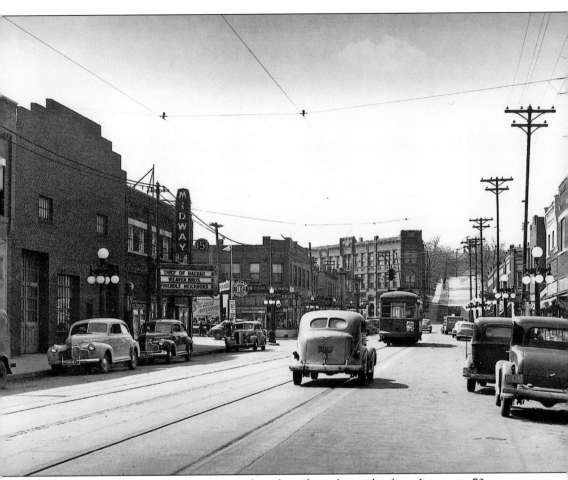

Central Avenue is a major business, retail, and residential corridor from Interstate 70 west to Twenty-fifth Street. In 1940, a ticket to the Midway Theater (645 Central Avenue) was 15¢. HC's Sinclair filling station, on the southeast corner of Seventh Street, was pumping regular gas for 11.9¢ per gallon and "ethyl"/high-octane for 13.9¢! The building at right center was the Simpson Block. It was demolished in the 1980s and converted to green space.

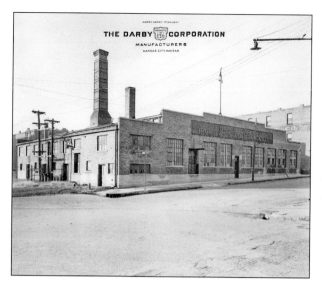

Harry Darby Jr. purchased the business in the Fairfax Industrial District from his father in 1938 and led it to becoming one of the largest steel plate manufacturers in the United State's. Its peak operations came during World War II, when more than 1,300 small warships were built and sent down the Kansas, Missouri, and Mississippi Rivers to New Orleans to head overseas. Darby was appointed in 1950 to complete the US Senate term of Clyde Reed. Both were Republicans. Darby died in 1987 at the age of 91. Darby Corporation was closed in 1989.

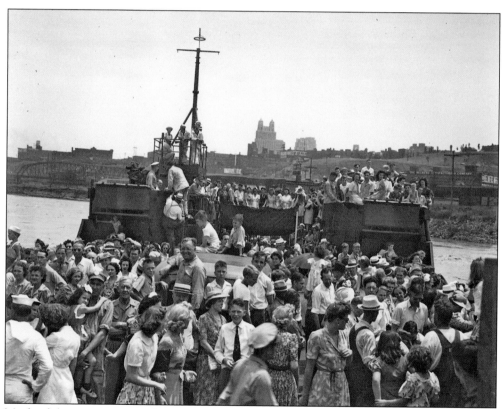

Much of the equipment used to win World War II was manufactured in Kansas City, Kansas. This photograph shows the public dedication celebrating the launch of another Darby-built warship headed into battle. After the war, the Darby Corporation continued to manufacture ships, locomotives, and railroad products and a broad range of items requiring steel components. The south end of the plant site is now a part of Kaw Point Park, where Lewis and Clark passed in 1804 and 1806.

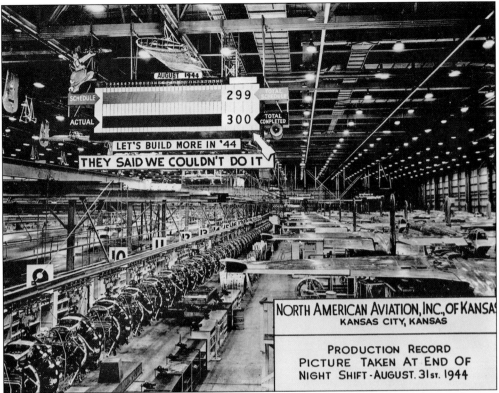

AUGUST 1944

SCHEDULE 299 TOTAL SCHEDULE

ACTUAL 300 TOTAL COMPLETED

LET'S BUILD MORE IN '44

THEY SAID WE COULDN'T DO IT

NORTH AMERICAN AVIATION, INC., OF KANSAS
KANSAS CITY, KANSAS

PRODUCTION RECORD
PICTURE TAKEN AT END OF
NIGHT SHIFT - AUGUST. 31st. 1944

The employee sign above expresses the zeal of the people who had reached the goal in production of the B-25 Bomber. The B-25 was a sleek, fast bomber that played a key role in the "Raid over Toyko." While aircraft were used in World War I, superior aircraft used by the Allies pushed enemy combatants into submission with lightening speed and efficiency in World War II. Many Kansas City, Kansas, residents worked here to help defeat Hitler and Hirohito.

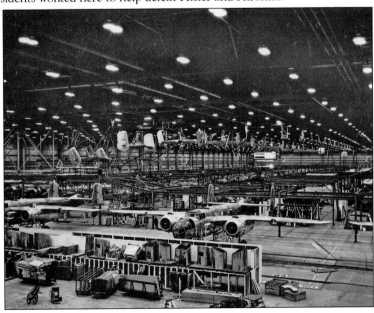

In this image, the day-to-day assembly line is shown inside the North American Aviation Plant in the Fairfax Industrial District. Workers were diligent because of deadlines to meet production goals. Soldiers throughout the military needed these bombers not just to defeat the Germans and the Japanese, but to save the lives of civilians.

65

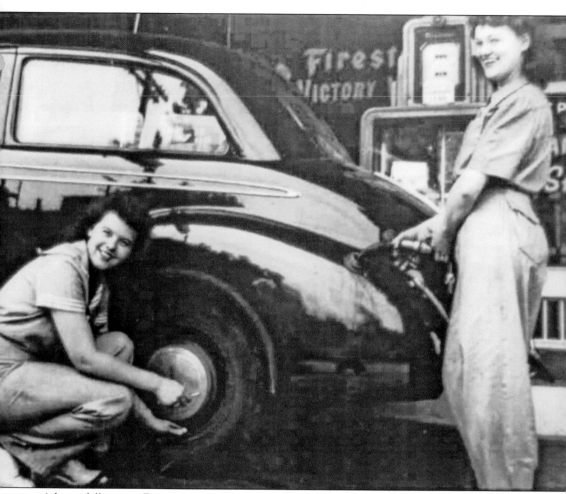

A large, full-service Firestone store was operated by the Jennings Brothers at 624 State Avenue for decades. During the war, with so many of the men away, women filled in at the service station, as seen in this photograph. There was no self-service in that era, and ladies ran the pumps, wiped windshields, and checked dipsticks and tire pressure. Younger readers may need to be informed that the dipsticks measured oil level; they weren't the drivers!

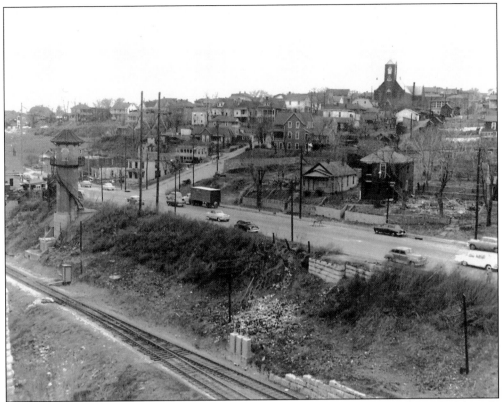

The photograph shows the Historic Strawberry Hill neighborhood as it appeared in 1954, relatively unchanged for decades. This is where many of the earliest Wyandotte Countians settled after immigrating from Europe in search of freedom and a better life. These residents worked for the packinghouses, soap companies, and early businesses that formed the city's strong and stable industrial base.

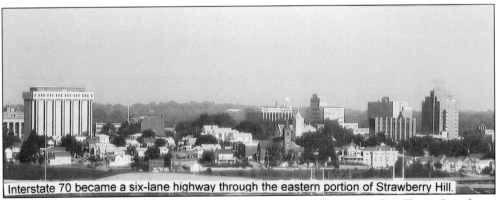

Interstate 70 became a six-lane highway through the eastern portion of Strawberry Hill.

What a change 50 years made in the fast-paced post–World War II decades. This is Strawberry Hill after the interstate highway system (I-70 and I-670) caused the demolition of one-fourth of the proud neighborhood. Although geographically much smaller, the Hill's spirit remains strong. And just as 100 years ago, many of the Asian and Hispanic immigrants coming to Kansas in the 21st century find a home on the Hill.

Sumner High School, seen here, stood on the northwest corner of Ninth Street and Washington Boulevard, from its completion as the only all–African American high school in Kansas at its opening until the new Sumner opened at Eighth Street and Oakland Avenue in 1947. African Americans were proud of Sumner, which was built in the historic Struggler's Hill district of Kansas City, Kansas.

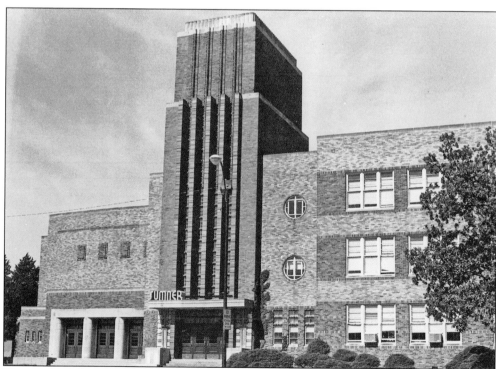

The new Sumner High School continued to be a hallmark of the city's African American history. Countless people from Sumner rose from the poverty of youth to attain local, regional, and national prominence. Under a court-ordered desegregation plan, Sumner ceased to exist in its traditional form in 1977 and has operated since as Sumner Academy of Arts and Sciences.

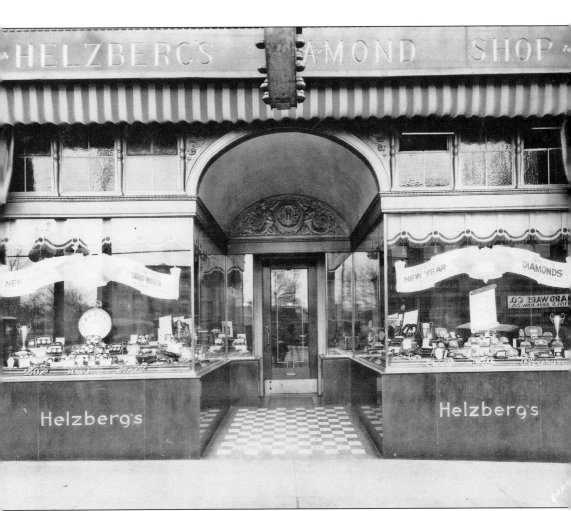

Helzberg's, with the slogan "The Middle West's Leading Jewelers," was founded in 1914 by immigrants from Russia. This location, at 612 Minnesota Avenue, was replaced by a gleaming new edifice at 654 Minnesota Avenue. The newer location featured showcase windows and bright lighting with lots of neon signage along the west side and south front of the corner location.

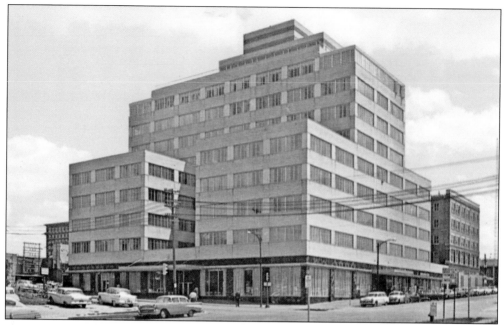

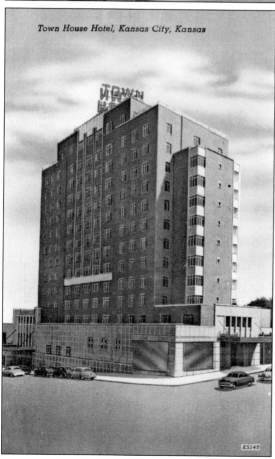

Town House Hotel, Kansas City, Kansas

In 1949, the world headquarters of the International Brotherhood of Boilermakers, Iron Ship Builders, Blacksmiths, Forgers & Helpers (AFL-CIO affiliated) was completed at 753 State Avenue. A luxury private club for businesspeople, The Terrace Club, occupied the ninth and tenth floors. The Boilermakers located in Kansas City, Kansas, over 125 years ago because it was nearly equidistant from the Gulf Coast and the Atlantic and Pacific Oceans.

The 15-story, 257-room Town House Hotel was the talk of the town when it opened in August 1951; it had been more than two decades in the planning. The $2-million building was financed by public subscription of the citizenry in a time before such facilities could get federal grants, foundation money, and similar public funding. The Kansas Room (Grand Ballroom) could seat 1,000 people.

This view shows the south side of the Town House at 1017 North Seventh Street Trafficway. The Teepee Room Café on the first floor featured a goldfish bowl. One of the highest-quality ladies' stores, Hennessy-Hardy, operated on the Seventh Street side of the hotel. Mrs. Hardy was known for specialized attention to the woman seeking a specific style or outfit. If she didn't have it, she would get it. That kind of customer service in the 21st century is hard to find. The nearby retail stores in the image are Adler's and Helzberg's.

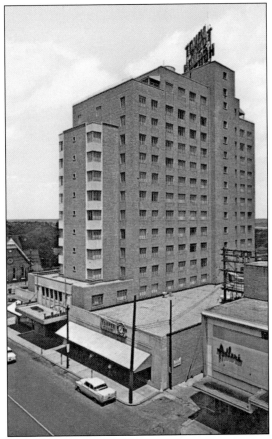

This is a view of the Rosedale District's main street, Southwest Boulevard, in the middle of the last century. Some of the better-known businesses along the "Boolie-Boolievard," as it was known to locals, were Strasser Hardware, Clasen-Morese Chevrolet, Rosedale Bar-B-Q, Rosedale Tire Service, the Rushton Bakery (a new building, still standing, replaced the first one destroyed by fire in 1917), and Rosedale State Bank.

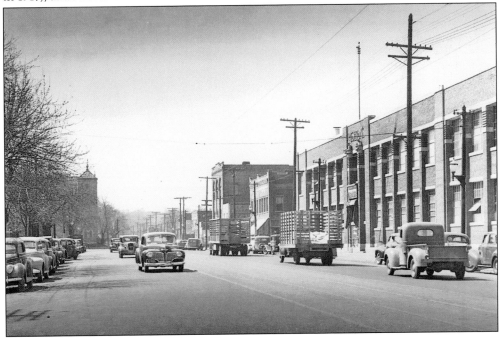

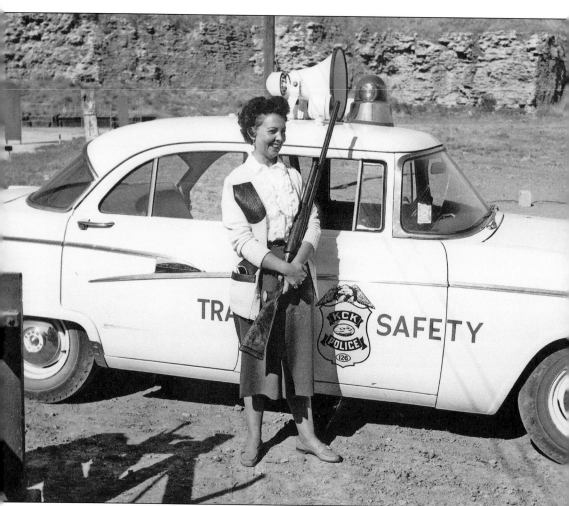

Women on the police force was a reality in Kansas City, Kansas, as early as mid-century, as this 1952 photograph indicates. This department employee was "packing heat," and the huge siren and large red emergency light atop to vehicle looked official. In 2012, the Kansas Highway Patrol is celebrating its 75th anniversary by bringing back bubblegum-machine-shaped rotating red lights.

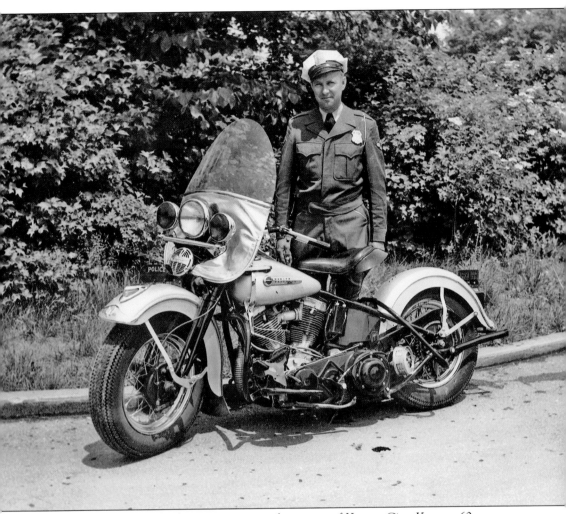

Police officers on two-wheelers were cruising the streets of Kansas City, Kansas, 60 years ago, using speed traps to search for "lead-footed" drivers. And in the 1940s and 1950s, traffic court was broadcast live by the *Kansas City Kansan* newspaper's KCKN Radio. KCKN did not have a network affiliation and so made its name on full-time, local programming. Maybe such live broadcasts in that era encouraged people to obey the law and to thus avoid being embarrassed by having it "heard on the radio."

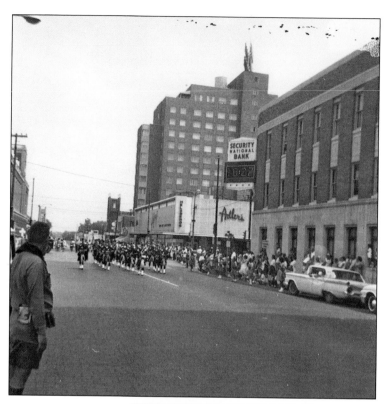

The annual Memorial Day Parade, which moved east on Minnesota Avenue to Seventh Street and then south to Memorial Hall, attracted large crowds in the years after World War II and the Korean conflict. This view looks northbound on Seventh Street from Armstrong Avenue. A military ceremony followed inside the hall. The Memorial Day Parade tradition began to rapidly fade away when all of the many controversies boiled up over the Vietnam War in the late 1960s.

People love a parade, and kids *really* love parades. This horse-drawn wagon is headed eastbound in the 800 block of Minnesota Avenue in front of Montgomery Ward's. For a few years, Kansas City, Kansas, had the moniker "City of Festivals." And festivals usually include a colorful parade! Although there is no date available for this image, it may have been in the 1950s, perhaps as a part of Wyandotte County's 100th anniversary.

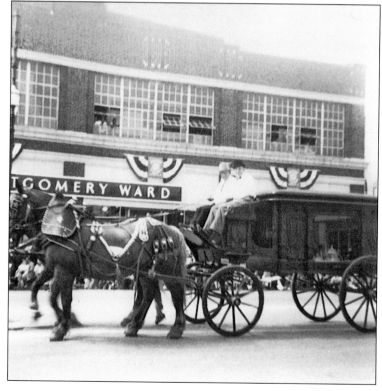

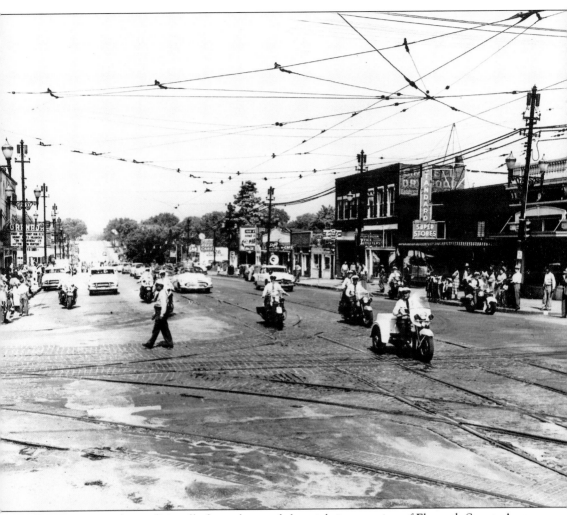

Downtown parades traditionally formed around the triple intersection of Eleventh Street, Ann Avenue, and Waterway Drive, a block south of Minnesota Avenue. They usually ended at Memorial Hall at Seventh Street and Barnett Avenue and preceded a program or event in the 3,500-seat auditorium. Note the complex set of streetcar tracks in this view of Tenth Street and Minnesota.

The 236-mile long Kansas Turnpike opened in the fall of 1956 as a four-lane, median divided highway connecting Kansas City, Kansas, to the Oklahoma border, via Topeka and Wichita. Singing cowboy Gene Autry and television's Annie Oakley (Gail Davis) cut a ribbon at the new Interstate 70 and Eighteenth Street Expressway to officially christen the new road.

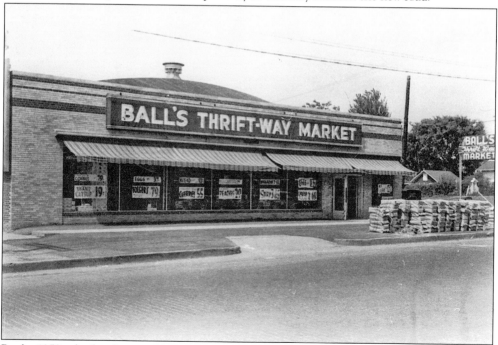

By the 1950s, the family-owned grocery store with a 25-foot frontage and living quarters over the business was giving way to the new era of supermarkets. Ball's Thriftway at 3400 State Avenue was among the first in Kansas City, Kansas, with a 75-foot frontage and adjacent parking for over 50 cars. A&P, Kroger, and Safeway were among the first national chain stores.

Wyandotte County celebrated its 100th anniversary in August 1959, as this program cover shows. The celebration lasted a full week, ending with a Saturday evening show at the Wyandotte High School football stadium at Twenty-second Street and Armstrong Avenue. Citizens dressed up in costumes all week. Men were required to grow at least a moustache—or risk being dipped in a dunk tank. It was all in fun.

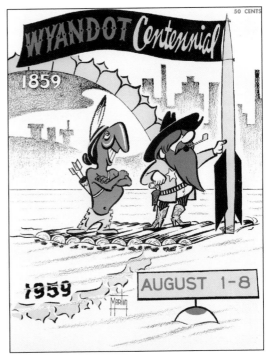

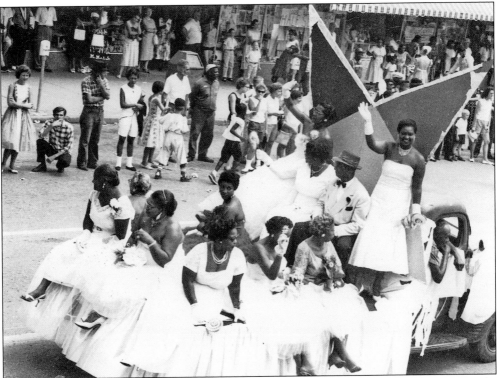

As many as 100 colorfully decorated floats participated in the 1959 centennial celebration parade, which ran some 20 blocks, from near Wyandotte High School down The Avenue to Fifth Street. This group from Sumner High School offer a typical example of the event's pageantry.

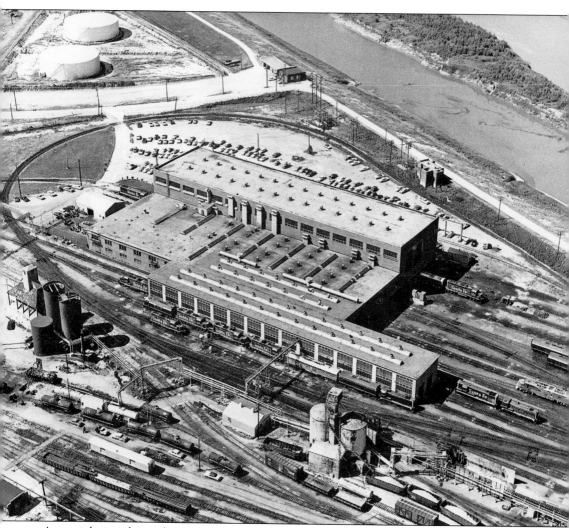

An aerial view shows the massive Santa Fe–Burlington Northern diesel engine maintenance shops west of Twenty-second Street and north of Strong Avenue in the Argentine District of Kansas City, Kansas. The executive offices of Santa Fe have always been in Topeka. The Shops have been in Kansas City, Kansas, as far back as the 1870s. Burlington Northern merged with the Atchison, Topeka & Santa Fe in the 1990s and became BNSF.

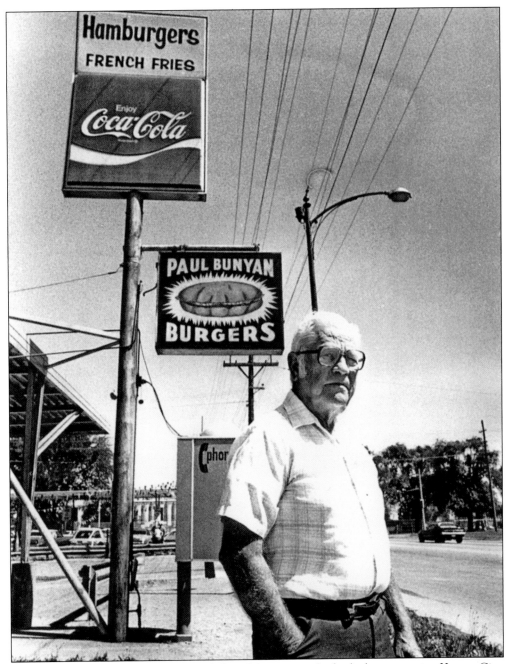

Paul Bunyan was a fictitious lumberjack from Minnesota who had a huge appetite. Kansas City, Kansas, entrepreneur Roy Hill is seen here at one of his approximately 10 drive-ins across town. The drive-up aspect was novel for a few years. Then, the much larger and heavily financed McDonald's and Burger King hit town, and Paul Bunyan became a part of history.

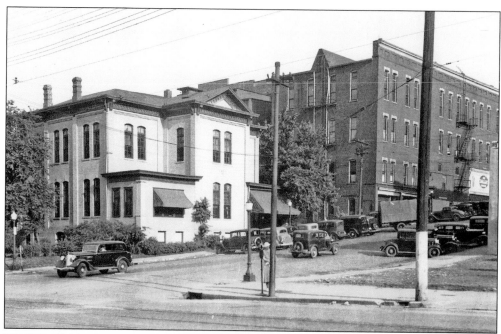

In the era of racial segregation, the YWCA (on the left) at 1017 North Sixth Street was the "white women's YW." The building in this photograph was demolished and replaced by the current building in 1958. The original structure, originally built around 1900, was Lincoln Elementary School and was a segregated black school until it was closed and sold to the YWCA.

These ladies are standing in front of the black women's YW on the southeast corner of Thirteenth Street and Washington Boulevard. The structure previously housed the Fraternal Order of the Eagle's Lodge. The Black YW purchased it after leaving the "Yates Center YWCA," which was located for many decades on the northeast corner of Seventh Street and Quindaro Boulevard.

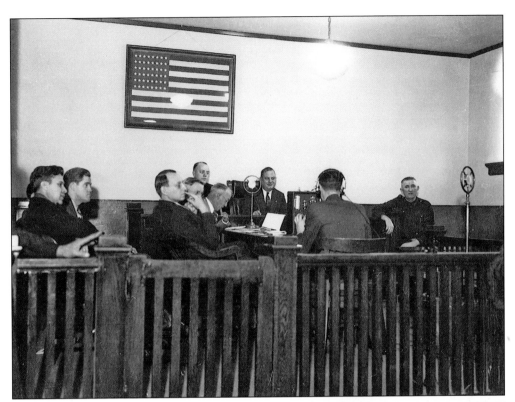

Kansas City, Kansas, had a version of *Judge Judy* about 50 years ahead of television. Yes, Judge *Lee* Judy is shown conducting daily business in Municipal Court at City Hall, 801 North Sixth Street. There was no way for offenders to hide from their legal indiscretions, because municipal court sessions were broadcast live on KCKN Radio.

When the Kansas City Public Levee Terminal Grain Elevator was in full operation in the late 1930s through the mid-1940s, KCKN's Frances Casement went to the terminal to report on the daily grain prices. Although considered the most urban county in Kansas in 2012, before World War II, the western half of Wyandotte County was largely agricultural. KCKN's signal went out about 75 miles in all directions, into adjacent farming counties. In 2012, 4-H programs still flourish in the county.

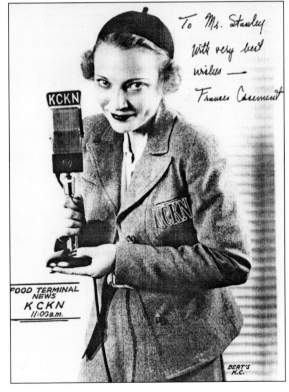

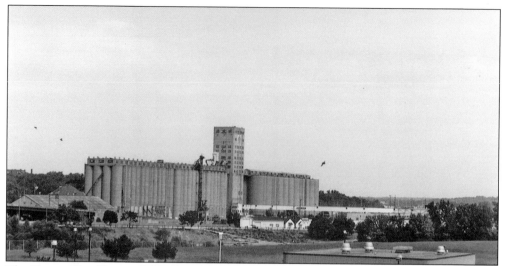

The Kansas City, Kansas, Public Levee Terminal (shown) was where KCKN's Casement went to file the daily grain reports. It was located at 3201 Fairfax Trafficway in Fairfax, on the eastern edge of downtown. The elevator tower has 18 levels. Grain was brought to this huge facility from central and western Kansas by truck and by rail. The Public Levee Terminal was adjacent to the Missouri River, which allowed sales and then shipping by barge on the river.

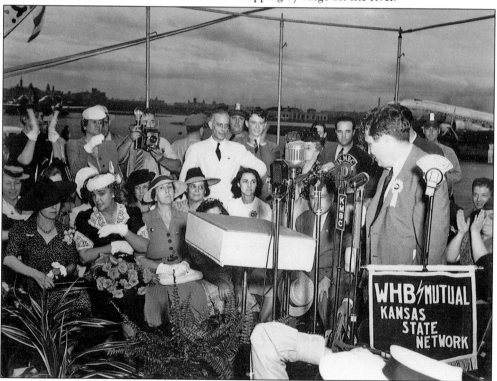

Wendell Willkie was the 1940 Republican Party presidential nominee. Live broadcasts from parks, government meetings, and other remote locations was a staple of local radio stations prior to the time when broadcasting evolved into deejays and 45-rpm records. Willkie lost to Pres. Franklin D. Roosevelt, allowing the Democrat an unprecedented third term in the White House.

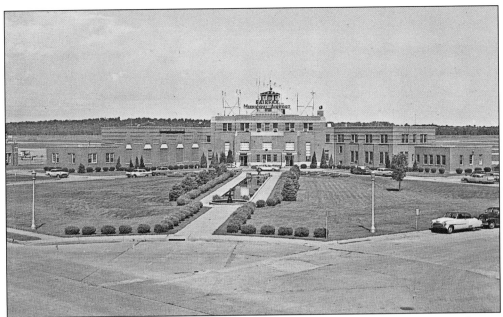

Fairfax Municipal Airport opened as a general aviation airport in 1927. It also served the adjacent 1,800-acre Fairfax Industrial District, as well as commercial airline service. The finely crafted yellow-brick Art Deco terminal had restaurant and meeting facilities. The north-south runway was 7,300 feet long, a long runway in the 1920s. The airport was demolished in 1985 to make way for the $1.5-billion General Motors Plant. This saved 4,000 jobs in Kansas City, Kansas.

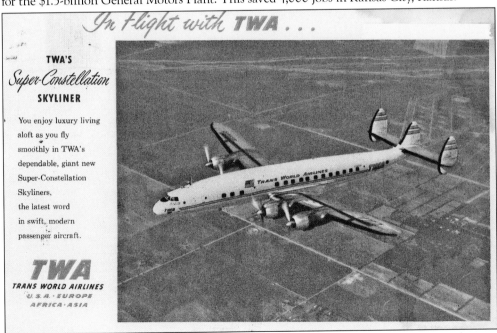

TWA's legendary Lockheed Super Constellation was housed at Fairfax. The "Connie," as it was known, was designed by eccentric billionaire Howard Hughes in the period when he owned TWA. The company's world headquarters was in Kansas City, Missouri, at that time. The distinctive "triple-tailed" luxury liner cruised at 350-mph—a very fast airplane in the 1940s and 1950s.

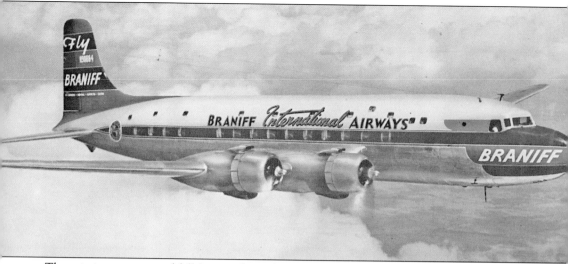

The aviation age emerged full force at the end of World War II. Cities with airports fought to have scheduled commercial airline passenger service as a matter of civic pride. Braniff served Fairfax with planes like this four-engine DC-6 "Conqueror." By 1960, commercial service was consolidated to Kansas City, Missouri's, Municipal Airport. KCI replaced it in November 1972.

Six

THE 1950S CONTRAST THE GREAT FLOOD OF 1951 WITH POSTWAR HUBRIS

Sunshine Biscuits, at 801 Sunshine Road, in the Fairfax Industrial District of Kansas City, Kansas, has remained fully operational since it opened in this beautifully designed industrial structure in 1947. The north-facing front of the building, in white-painted concrete bordered by red brick, rises about 75 feet. A large silver clock is near the top, making it appear more like an academic building than an industrial structure. This company was founded as the S.C. Whiles Baking Company of Kansas City, Missouri, a century ago. Nabisco owned it for a time. Keebler Crackers is the present owner of the brand name.

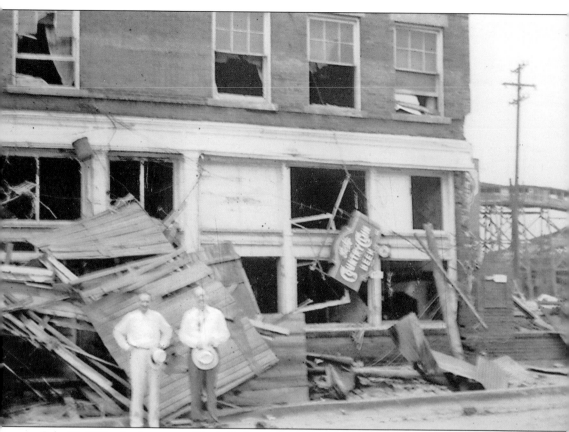

July 13, 1951, also known as Black Friday, will never be forgotten in the Kansas and Missouri River valleys. That was the date floodwaters peaked during what may have been the worst flood in eastern Kansas and western Missouri since record keeping began in the late 1800s. The water crested midway up second-floor windows. It took months to clean up the debris after the flood. That event marked the beginning of the end of the stockyards in the two Kansas Citys. Reportedly, 22 percent of the land area of Wyandotte County was under water in 1951.

Young's Department Store, at 542 Minnesota Avenue, was a locally owned, full-line department store that operated for decades in downtown Kansas City, Kansas. Young's was destroyed in a fire on a subfreezing night in February 1958 and never reopened. The only similar independent store still in business in the region is Weaver's Department Store, 901 Massachusetts, in Lawrence.

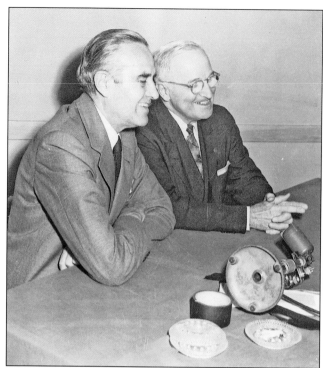

Here is a fine example of bipartisan political chat on live radio in 1950. Kansas Republican governor Frank L. Hagman (left) talked about issues of the day with Pres. Harry S. Truman, a Democrat. And both men are smiling! This photograph was taken in the radio studios of KCKN in The Kansas City Kansan Building at 901 North Eighth Street.

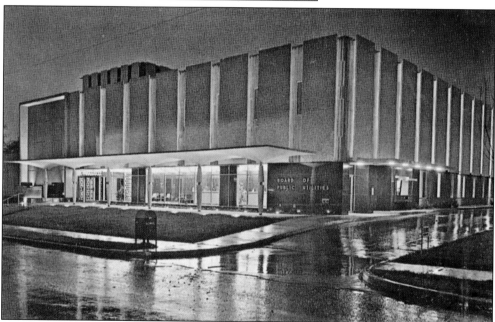

The Kansas City, Kansas, Board of Public Utilities (BPU/Water and Lights) moved into its first headquarters, at 1201 North Eighth Street, in 1959. The BPU was created by an act of the Kansas Legislature in 1929. For the first 30 years of its existence, it had been in city hall, at 801 North Sixth Street. In the early 1970s, the BPU moved into the former Montgomery Ward's Store at 700 Minnesota Avenue. Presently, the Eighth Street structure houses the US Census Bureau's regional office for Missouri, Kansas, Iowa, and Nebraska.

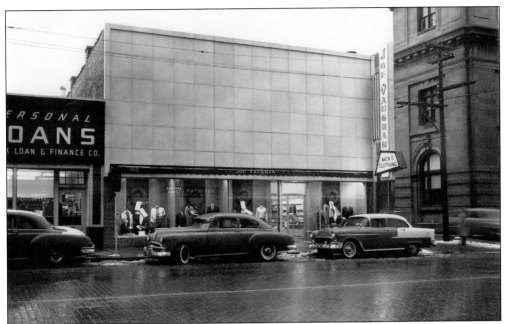

In March 1955, Joe Vaughan Men's Clothing opened in this new 5,000-square-foot facility at 910 North Seventh Street Trafficway, just across the street from 913, where the store had been since 1933. The business originally opened June 9, 1928, at 1716 Central Avenue. Security Bank and Vaughan Clothing both moved from Eighteenth Street and Central Avenue to The Avenue in 1933. A third-generation Kansas City, Kansas, businessman, Vaughan used the phrase "Your resident-owned, quality men's store" in advertising and promotions.

The Koppel family owned and operated this high-quality women's clothing store at 740 Minnesota Avenue from the 1930s through the 1970s. The store had a reputation for stocking name-brand merchandise and providing personal customer service that was a hallmark of retailing in the 1950s. Avenue shoppers may recall that a bowling alley operated on the second floor over Kay's and Douglas Optical. The sound of bowling balls clanking around and pins crashing are a memorable contrast to the usual downtown traffic and diesel bus engines roaring.

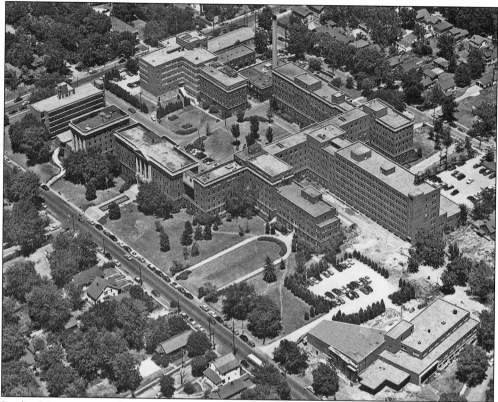

In the 30 years since the original building was dedicated in 1924, KUMC had expanded the 3901 Rainbow Boulevard campus to cover approximately 12 square city blocks, as this aerial view shows. It had steadily grown in research and patient services as well as national recognition among teaching hospitals. It was one of the region's largest employers, providing jobs for over 4,000 people by the mid-1950s.

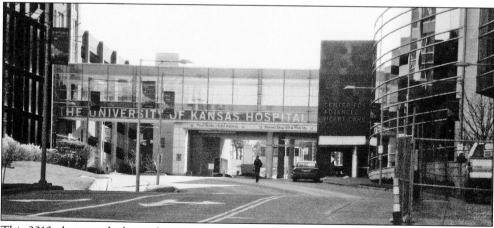

This 2012 photograph shows the main entrance to the University of Kansas Hospital just west of Thirty-ninth Avenue and State Line Road in Kansas City, Kansas. Although still sharing the same vast campus, the University of Kansas Medical Center and the University of Kansas Hospital were reorganized into separate operating entities. The key reason for the change was in order to meet the distinct needs of operating in the business structure of 21st-century medicine.

Seven

THE TOUGH YEARS OF TRANSITION

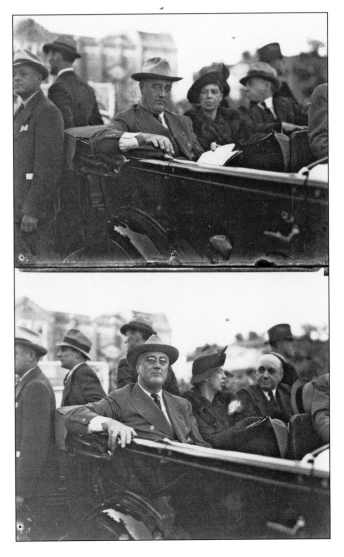

Pres. Franklin D. Roosevelt visited Kansas City, Kansas, on October 13, 1936, during the presidential campaign. He was running against Kansas governor Alf M. Landon on the GOP side. The only indication in the photographs of the location is the fact that the Scottish Rite Temple at 801 North Seventh Street Trafficway is visible in the background. It appears Roosevelt's motorcade was southbound on Seventh Street in front of the courthouse. FDR swamped Landon, taking 46 of the 48 states in 1936. The only states Landon won were Maine and Vermont.

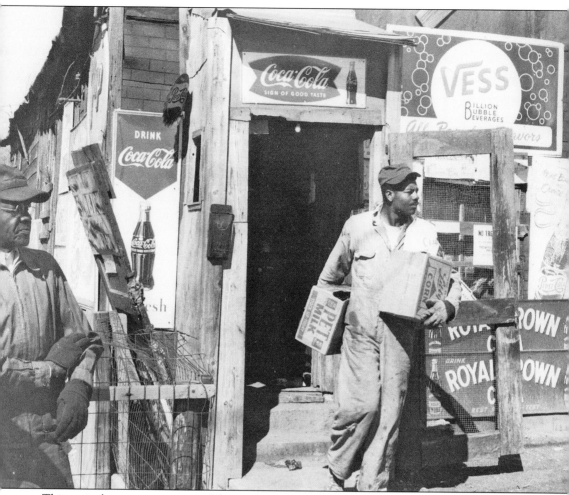

This typical grocery store in an African American neighborhood appears to be shown on a hot summer day, with customers coming and going. The man to the left has gloves on and appears to be catching his breath following a hard work day. The soda pop signage (some no longer around) was often the way stores pulled people in for a break and to make a purchase on sunny Kansas days. The location of this store is not known.

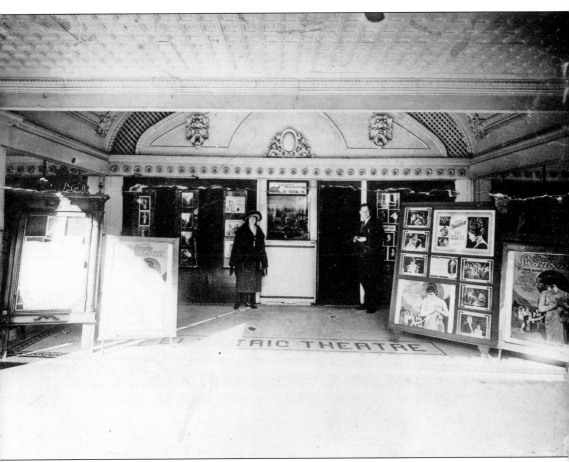

The ticket booth and double entrance to the Electric Theatre (546 Minnesota Avenue) show the theater's name in the tile flooring. This theater was elegant and overbuilt even for the times. On the west side of the main entrance there was a popcorn, candy, and soft drink store. For unknown reasons, owners and managers never caught on to how many patrons got in free by entering the refreshment stand from the street, then blending in with the crowd before walking into the main theater without paying for a ticket.

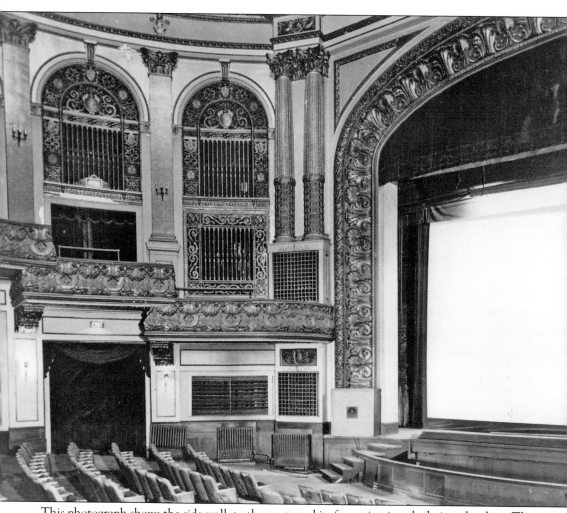

This photograph shows the side wall, to the west, and its fancy, intricately designed styling. The wall was high because this is an extension between the screen and the balconies. The height is equivalent to about four stories.

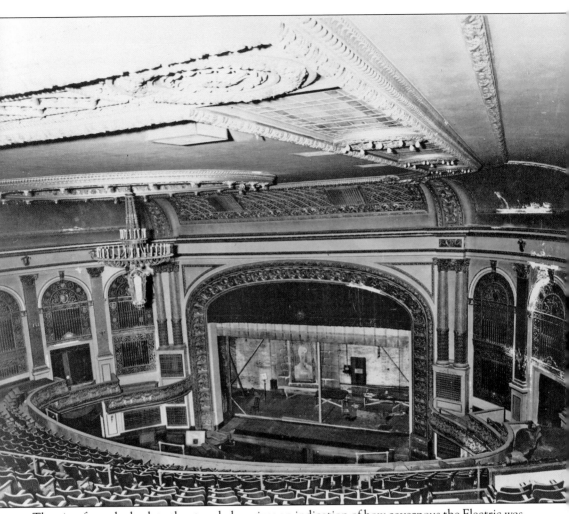

The view from the back to the stage below gives an indication of how cavernous the Electric was. The distance from the top to the stage was approximately equal to a half-block on a city street.

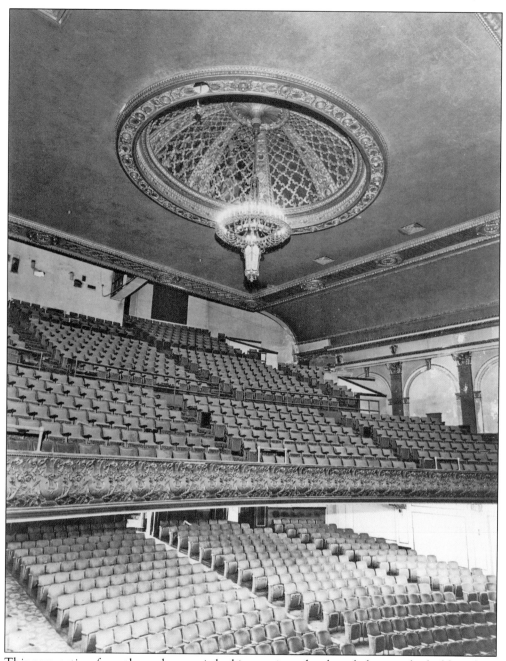

This perspective, from the orchestra pit looking up into the three balconies, looks like a long way—and it was! The Electric had a 100-foot frontage along The Avenue's north side. The space allowed for both a wide and a deep structure for theatergoers.

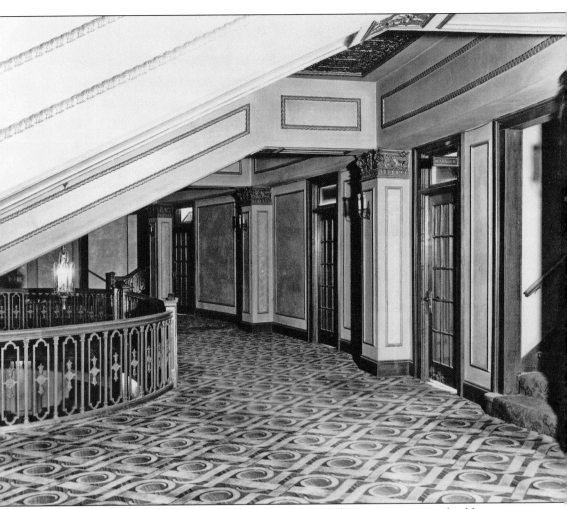

The wide, curving corridor between the balconies allowed theater patrons considerable space to move around. The Electric's wide concourses were built to handle the large volumes of patrons that would be moving around in the 1,750-seat showcase.

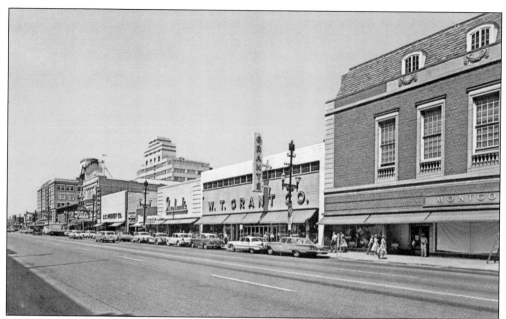

This photograph of the 700 block of The Avenue in downtown's shopping heyday depicts women still shopping in dresses and cars with big tail fins. The Avenue thrived to the point that these merchants had two locations: Katz Drug, J.S. Lerner's Vogue, Askin's Credit Clothing, and Montgomery Ward. In addition to Montgomery Ward, other businesses pictured above include W.T. Grant, Shepherd's, Mode-O-Day, Katz Drug, Zale's Jewelry, Cake Box Bakery, Wyandotte Lodge No. 3, Kay's Fashions, and Harper's Rugs.

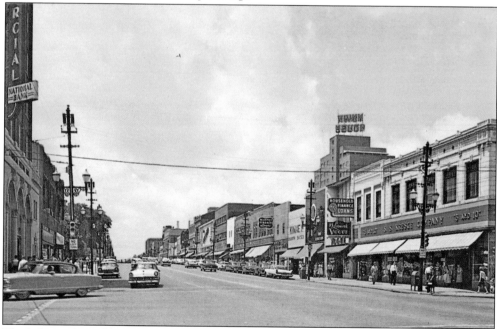

The halcyon days of downtown as a retail hub and an office center occurred in the late 1950s and early 1960s, before suburban shopping centers began to siphon off development. This view is of the north side of the 600 block of "The Avenue," as Minnesota was referred to, looking west.

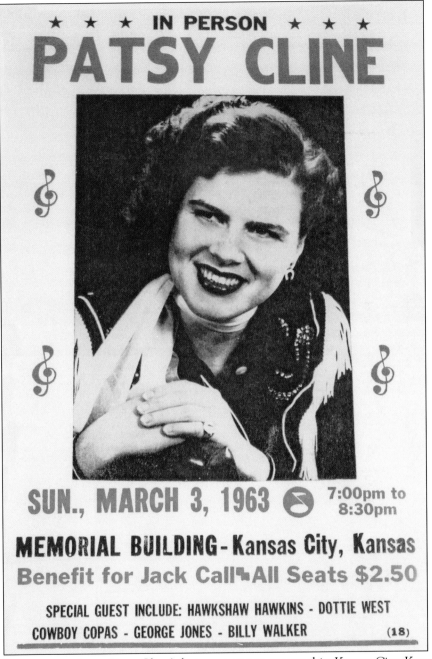

★ ★ ★ IN PERSON ★ ★ ★
PATSY CLINE

SUN., MARCH 3, 1963 7:00pm to 8:30pm

MEMORIAL BUILDING - Kansas City, Kansas
Benefit for Jack Call - All Seats $2.50

SPECIAL GUEST INCLUDE: HAWKSHAW HAWKINS - DOTTIE WEST
COWBOY COPAS - GEORGE JONES - BILLY WALKER (18)

Legendary country singer Patsy Cline's last appearance occurred in Kansas City, Kansas, on Sunday, March 3, 1963, before her death in a plane crash near Nashville. Ironically, Cline appeared at Memorial Hall, 600 North Seventh Street Trafficway, in a benefit performance on behalf of the late KCKN-AM and KCMK-FM deejay "Cactus Jack" Call. He had died in an automobile crash a few weeks earlier. Cline's single-engine plane took off from Fairfax Airport in a blinding snowstorm and crashed in the same weather conditions just 90 miles from its destination. Like Buddy Holly and James Dean, Patsy Cline's iconic status continues to grow nearly 50 years after her tragic death.

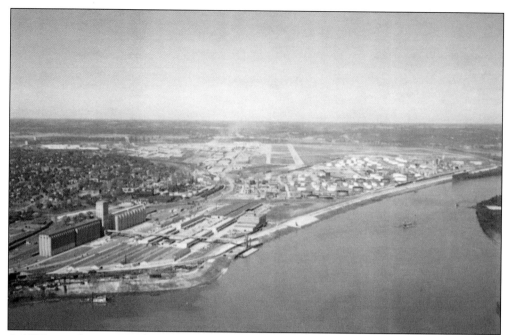

A 1950s aerial view provides some visual perspective on the vastness of the Fairfax Industrial District, looking north over the mouth of the Kansas River at its junction with the muddy Missouri. At lower left is the Kansas City, Kansas, Public Levee Terminal grain elevators and adjacent grain operation and offices. A nearby barge dock, and barges on the Missouri, are visible. At right center is the Phillips Petroleum Company, which operated from the beginning of Fairfax until 1997. In the top center of the photograph is a view of the municipal airport. And to the left can be seen the tens of dozens of brand-name industries and manufacturers whose goods were shipped to all parts of the nation from Kansas City, Kansas.

Republican presidential nominee Vice Pres. Richard Nixon is shown (center) campaigning at Fairfax Airport in September 1960. Nixon went on to lose the 1960 race to Massachusetts senator John F. Kennedy. Nixon refused to wear makeup for the first televised presidential debate, and his five o'clock shadow contrasted with the youthful-looking JFK. It is one reason that many seasoned observers believe Nixon lost.

Hundreds of Republicans turned out on a cloudy September afternoon to see 1960 Republican presidential candidate Richard M. Nixon and his wife, Pat, in front of the terminal at Fairfax Municipal Airport. This was a typical campaign stop in the era. A candidate would fly in to meet a crowd that his supporters had gathered. A large flatbed was brought in and the candidate stood atop it and addressed the partisan crowd. It worked at Fairfax in 1960!

Anderson's Furniture Store was a fixture in downtown Kansas City, Kansas, for some three generations, spanning over 80 years. When Carl Anderson was advanced in years, and having no family members to take over the business, he closed the store at the end of 1960. ABC Furniture operated in the location for a few years after urban renewal forced it out of the 500 block of Minnesota. Since 2000, the Anderson Building has been the regional home of the Mental Health Association of the Heartland.

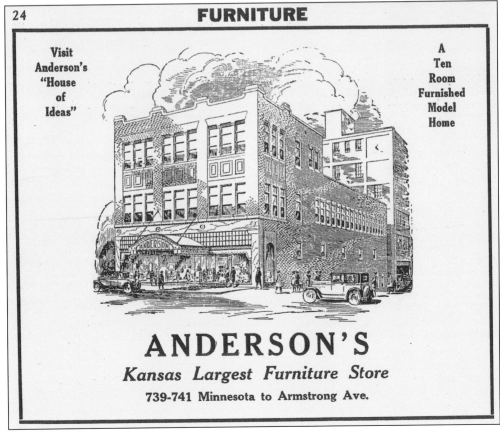

24 **FURNITURE**

Visit Anderson's "House of Ideas"

A Ten Room Furnished Model Home

ANDERSON'S
Kansas Largest Furniture Store
739-741 Minnesota to Armstrong Ave.

The decline of downtown Kansas City, Kansas, came so fast and hit so hard after the opening of Indian Springs' 700,000-square foot enclosed mall that a pedestrian mall was built in the 600 and 700 blocks along The Avenue in November 1971. The fountain (shown) was at the west end of the mall in front of the Brotherhood Building and was supposed to depict how Kansas creeks and streams gently flow across the natural limestone formations. The two-block-long pedestrian mall failed miserably because of parking problems and retail competition from enclosed malls like the one in Indian Springs. The Center City Mall, as it was known, was completely demolished and the conventional asphalt street rebuilt by 1976. Literally all of the many stores named earlier had closed downtown locations by 1980. Many of the spaces stood empty until entrepreneurs among the new Hispanic immigrants began to fill the storefronts in the 1990s.

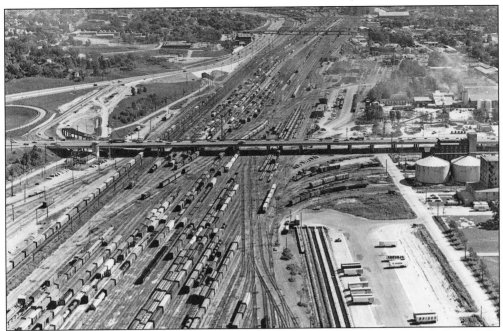

This is an aerial view looking toward the east over the rail yards of the Union Pacific and the now-defunct Rock Island Railroads. The several-hundred-acre site is oval-shaped and bounded by Interstate 70 south to Kansas Avenue and Thirty-eighth Street east to the Missouri state line.

The United Way traditionally holds the biggest community-wide fundraising event of the year in cities and towns across the United States. The employees of Union Pacific painted this engine and took it through several yards like a rolling signboard. In earlier years, the same fund drive was known as the Community Chest.

Deborah Irene Bryant, 19, of Overland Park, Kansas, won the Miss America competition in 1966. She is shown here in a parade down Minnesota Avenue. Bryant had won the Miss Kansas City, Kansas, Pageant sponsored by the Kansas City, Kansas, Jaycees. She then gained the Kansas title at Pratt before moving on to win the national title in Atlantic City.

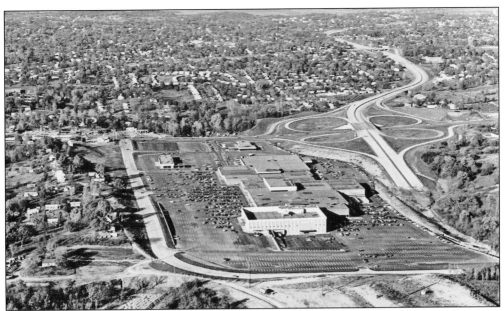

The Indian Springs regional enclosed shopping center opened at 4601 State Avenue in the spring of 1971. It occupied a 60-acre site and had surface parking for 5,000 cars. The anchor tenants were Montgomery Ward's, J.C. Penney's (both had moved from downtown), and Dillard's. There were over 100 stores in the mall or on pad sites in the parking lot.

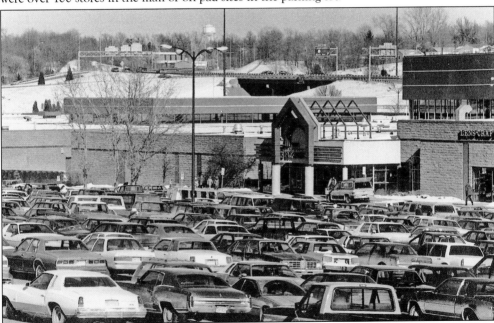

The 700,000-square-foot shopping mall had a full parking lot in its heyday, from 1971 until the early 1990s, when crime and many urban issues resulted in its being abandoned. The mall lost a major advantage it had enjoyed when the Missouri Blue Laws were repealed. During the laws' existence, no retail or "non-essential commerce" could be conducted in the state of Missouri on Sunday—defined in the law as the "Sabbath." Missourians used to fill the parking lots at Indian Springs and Metcalf South on weekends.

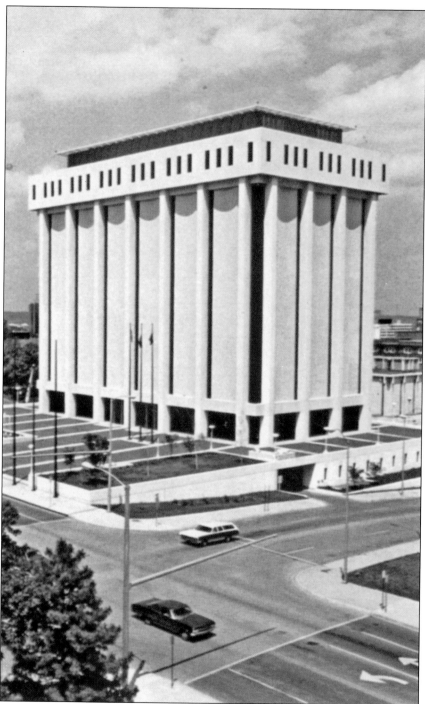

This is the fourth structure to serve as city hall in Kansas City, Kansas. The 11-story, $5.7-million building was dedicated in May 1973. The municipal building is at 701 North Seventh Street Trafficway and was the last building to be completed in the city's civic center, which had begun with the Soldier's and Sailor's Memorial Hall in 1924. Following the 1997 city-county consolidation, the building was renamed the Unified Government Building–East.

The Center City Urban Renewal project between 1968 and 1975 brought a lot of controversy to downtown Kansas City, Kansas. This view shows the 900 block of North Seventh Street Trafficway after the Sears Catalog Store moved to Tower Plaza Shopping Center at Thirty-eighth Street and State Avenue, with an opening date of the spring of 1966. Tower Plaza was on the former site of the Farmer's Market. It was the biggest single sign of the change that downtown was about to undergo.

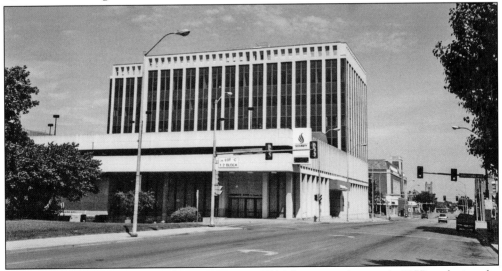

Security Bank completed its eight-story tower at 701 Minnesota Avenue in 1977, replacing the Sears Catalog Store, Pyramid Life Insurance Company, and the Jack Klaussen Coin Shop. This view of that same block shows a five-level parking garage with a capacity for 500 vehicles fronting the 700 block of Armstrong Avenue. It is connected to the bank building with an adjacent walk-through to The Avenue.

The 10-story Gateway Tower II at 400 State Avenue houses the Department of Housing and Urban Development, serving Kansas, Missouri, Iowa, and Nebraska. The building, completed in 1974, was constructed on ground cleared as a part of the Gateway Urban Renewal Project of the late 1950s. This was the largest premium office high-rise that opened in downtown Kansas City, Kansas, since the New Brotherhood Building was completed in 1949.

Eight

An Era of Consolidation, Literally and Figuratively

This mural was painted on retail buildings along the north side of the 600 block of Minnesota Avenue by Hispanic youths whose ideas to brighten up downtown have made a difference. Most of these old buildings have remodeled fronts and have been converted into offices and other professional spaces. The consolidation is due in part to the assimilation and increasing visibility of the Hispanic culture as part of the new, permanent Kansas City, Kansas, heritage.

The initial influx of Mexicans to Argentine, Kansas, started around 1905. Records indicate that migration was largely due to railroad jobs they could get with the Atchison, Topeka & Santa Fe as it was rapidly expanding in Argentine at the turn of the last century By the 2010 census, Kansas City, Kansas, had become a "minority-majority city," about evenly split between Hispanics, African Americans, and Caucasians. The colorful mural on the side of a downtown building shows the recent immigrants expressing their colorful heritage on a previously bare, red brick wall.

A tribute to the pressmen of an earlier time in the newspaper industry is shown on the north side of the former *Kansas City Kansan* newspaper building at 901 North Eighth Street. The sunflower (lower right) is the official state flower and was used in the paper's logo for many years. The *Kansan* occupied the structure for some seven decades before it was converted to office space.

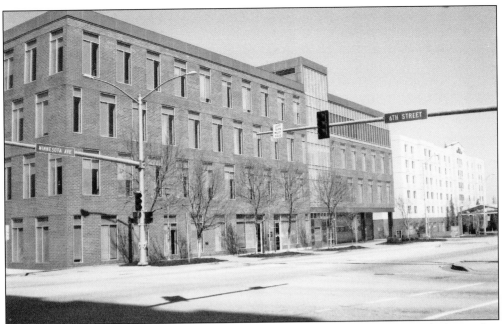

Images of the lavish Electric Theatre appear earlier in this book. This photograph shows what the same block looks like in 2012. The Board of Public Utilities headquarters (pictured) was completed in 2004, and the Hilton Garden Inn was added to the 1981 Jack Reardon Convention Center in 2003. This image shows the success of the first urban renewal project in the state of Kansas (Gateway, 1956), which brought vitality to a declining block.

This photograph of the same block looks west from Fifth Street and Minnesota Avenue. From this view, the Jack Reardon Convention Center, the Hilton Garden Inn Hotel, and the BPU headquarters reflect the area's modern era.

Although it was completed in 1981, the Jack Reardon Convention Center at 500 Minnesota Avenue was completely renovated during the construction of the Hilton. It has 20,000 square feet of exhibition space. For a large banquet, there is seating for 900 people. This marked the first time Kansas City, Kansas, had had a specifically designated convention location. In earlier years, large meetings were staged at the Town House Hotel, Memorial Hall, or at the National Guard Armory at Eighteenth Street and Ridge Avenue.

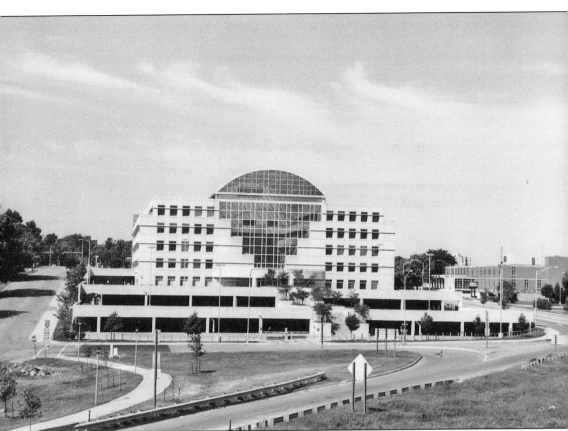

An entire city block, bounded by Fourth to Fifth Streets and Minnesota Avenue to Armstrong Avenue, was cleared of an abandoned motel to make way for the $20-million Environmental Protection Agency Region VII offices in 1993. The regional offices serve the states of Nebraska, Iowa, Missouri, and Kansas. The block was in the Gateway Urban Renewal zone. A large Holiday Inn had occupied the site since 1963, and, before that, furniture stores and other retail establishments were located there, in structures mostly built before 1900.

The Kansas Department of Social and Rehabilitation Services (SRS) occupied this five-story building until the growing space requirements of SRS led to this building being demolished in 2004 and a new, larger structure was built on the site. There is only one state government office building located in Kansas, City, Kansas. Other Kansas state offices are in rented space scattered across Wyandotte and Johnson Counties.

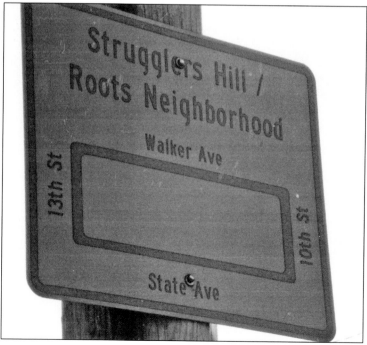

This sign designates the area where African Americans first lived in the years between the Civil War and the end of World War II. The boundaries of Tenth Street on the east, Thirteenth Street on the west, and from State Avenue north to Walker Avenue are marked so that the struggles the people fought to survive are never forgotten. The markers were posted in 2012.

Nine

21st-Century Technological Transformation Affects Everyone

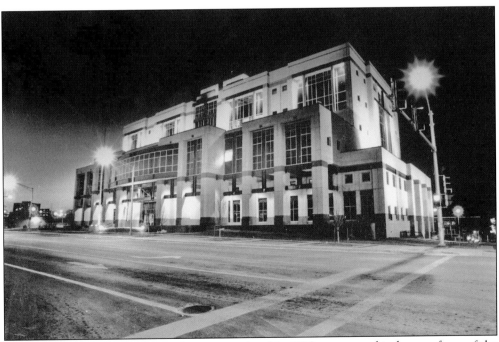

The Robert J. Dole Federal Courthouse, completed in 1993, was named in honor of one of the longest-serving US senators in Kansas history. Dole's distinguished career was capped in 1996 when he was the Republican presidential nominee. He lost to incumbent president Bill Clinton. The nine-story structure is located at 500 State Avenue.

ROBERT J. DOLE
UNITED STATES COURT HOUSE

HONORING MORE THAN 50 YEARS OF SERVICE
TO KANSAS AND THE NATION

1996 Republican Nominee for President; over 27 years in the U.S. Senate;
longest serving Senate Republican Leader, nearly 12 years; 8 years, U.S.
House of Representatives; 8 years, Russell County Attorney; 2 years,
Kansas House of Representatives

Captain, United States Army, 1942-1948
Bronze Star Medal and two Purple Hearts

AWARDED THE PRESIDENTIAL MEDAL OF FREEDOM
on January 17, 1997

DEDICATED MAY 15, 1998

A plaque detailing Sen. Robert J. Dole's career in law, the military, and politics is mounted on the southeast corner of the courthouse, facing State Avenue.

One of the first visible benefits after the 1997 governmental consolidation between Wyandotte County and its three cities was the acquisition of 400 acres of land northwest of I-70 and I-435 for the Village West development. Sales tax and revenue bonds ("STAR Bonds") were made legal by the Kansas Legislature to finance construction of major projects in the development. Kansas Speedway was the first construction completed, in 2001.

At a cost of $250 million, the International Speedway from Daytona, Florida, opened Kansas Speedway in 2001, at 400 Kansas Speedway Drive. The seating capacity is a little over 82,000. The track hosts two major NASCAR races annually and many other auto-racing circuit events throughout the racing season. A variety of smaller racing events, car swaps, and shows keep the track busy most weekends of the season.

The NASCAR events held at Kansas Speedway in its first decade of operation have drawn rave reviews from both the drivers and the fans. The biggest races have now been scheduled in the spring and fall months of the racing season because of the searing 100-plus-degree heat and high humidity that fans and drivers experienced in the first two years of track operations. During the 2012 season, the 1.5-mile oval track is due to be resurfaced and reconfigured as a part of normal maintenance.

There are over 100 stores in the Legends Discount Shopping Center, which opened in 2003 to the north of the speedway. Quality retail outlets were key for the Village West, which is financed by Kansas STAR (sales tax and revenue) Bonds. The 150-foot-tall smokestack is emblematic of city's roots as an industrial center whose best-known early employers were meatpacking houses.

The Legends 14 is a first-run movie theater in the center of the shopping district. A decade ago, Kansas City, Kansas, was said to be the only fully developed, 150,000-plus-population city in the Midwest that did not have an operating first-run movie theater. It has a state-of-the-art facility now.

Kansas has produced many nationally and internally known runners, from Jim Ryan, who broke the four-minute mile barrier in 1964, to Wes Santee, to "the fastest man alive," Olympian Maurice Greene of Kansas City, Kansas. These statues recognize the many record-setting Kansas runners. At one time or another, all have run at the legendary Kansas Relays, held each spring at Kansas University in Lawrence. The KU Relays are part of a spring series that begins with the Texas Relays, then the KU Relays, the Drake Relays, and ends with the Penn Relays.

Major League Soccer's (MLS) Sporting Kansas City, Kansas, came to town in 2011 with the completion of this glamorous $250-million LIVESTRONG Sporting Park, located across State Avenue from the Kansas Speedway. The new, world-class stadium seats over 18,000 and can be expanded to 25,000 seats in the future.

The crown jewel of the Village West complex may be the $411-million, 95,000-square-foot Hollywood Casino at Kansas Speedway, which opened on February 3, 2012. The most unique aspect of this casino is its location, on turn two of the speedway.

The neon-lighted casino faces the second turn on the speedway. An adjacent five-level parking garage with valet service means customers never have to go out into the ever-changing Kansas weather. There are five eating options, from cafes to bars and a swanky restaurant. The design is Art Deco inside and out. In its first month of operation in March 2012, Hollywood Casino brought in $11 million!

The new 10-story University of Kansas Hospital's Center for Advanced Heart Care is the latest center under construction on the 3901 Rainbow Boulevard Campus. Hospital officials say it will provide the latest technology and the most current treatments of any such facility in the United States. It is scheduled to have a new heart transplant facility in operation in 2012. The KU Hospital serves the entire state of Kansas as well as the metropolitan area on the Missouri side.

The growth of the KU Medical Center and the KU Hospital as well as the surrounding high-rise residential facilities has given the Rosedale district a distinctive skyline. At the center of the photograph, Rainbow Boulevard traverses the area south to the Johnson County line. Rainbow and Seventh Street parallel the Southwest Trafficway in Kansas City, Missouri, as the principal north–south traffic corridors in the two Kansas Citys.

The slogan on this sign sums up the feelings of many residents of "KCK": "Kansas City, Kansas . . . Not Your Ordinary Cowtown."

BIBLIOGRAPHY

Donald, Jefferson Edward. *Struggler's Hill: A People, A Community.* Northeast Cooperative Council and Light Bearers Entertainment, 2011.

Gibson, Betty S. *Pride of the Golden Bear.* Dubuque, IA: Kendall/Hunt Publishing Co., 1981.

Hancks, Larry E. *A Gift to the Future: Kansas City, Kansas Architecture.* Harriet Bigham, ed. Kansas City, MO: Ashcraft Publishing Co., Inc., 1988.

———. *Roots: The Historic and Architectural Heritage of Kansas City, Kansas.* E.R. Callendar, 1976.

Hanson, Harry E. *A Historic Outline of Grinter Place from 1925 to 1978.* Harry E. Hanson, 1978.

Landis, Margaret. "Then and Now" (column). Kansas City, KS: *The Kansas City Kansan*, 1986.

McDowell, Mayor Joseph H. *Building a City: A Detailed History of Kansas City, Kansas.* Kansas City, KS: *The Kansas City Kansan*, 1967.

Shutt II, Edwin Dale. *Centennial History of Argentine.* Kansas City, KS: Simmons Funeral Home, 1980.

Wyandotte County Museum and Historical Society Archives. Vertical files, photo files, library shelves. 1889–2012.

DISCOVER THOUSANDS OF LOCAL HISTORY BOOKS FEATURING MILLIONS OF VINTAGE IMAGES

Arcadia Publishing, the leading local history publisher in the United States, is committed to making history accessible and meaningful through publishing books that celebrate and preserve the heritage of America's people and places.

Find more books like this at
www.arcadiapublishing.com

Search for your hometown history, your old stomping grounds, and even your favorite sports team.